IMAGES
of America

MANHATTAN

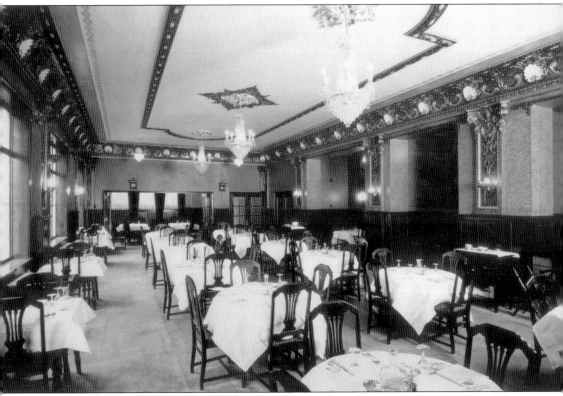

The elegant dining room of the Wareham Hotel is seen here shortly after its restoration following the 1951 flood. The Wareham served the well-to-do and hosted scores of special functions. In 2011, 2012, and 2013, its restaurant, Harry's, was listed as "One of the Top 100 American Cuisine Restaurants." (Photograph by Max Wolf; courtesy Riley County History Museum.)

ON THE COVER: This 1953 photograph of the Wareham Hotel, the Wareham Office Building, and the Wareham Theater reveals the upscale, ambitious downtown development efforts of Harry P. Wareham and his nephew, Harry K. Wareham. H.S. Moore built the theater as an opera house in 1884. H.P. Wareham bought it in 1893 and began showing motion pictures in 1910. He built the hotel, complete with penthouse, in 1925 and opened it for business in 1926. The hotel restaurant remains one of the city's best dining options. The hotel rooms have been converted to apartments. (Courtesy Riley County History Museum.)

IMAGES
of America

MANHATTAN

James E. Sherow

ARCADIA
PUBLISHING

Published by Arcadia Publishing
Charleston, South Carolina

Printed in the United States of America

Library of Congress Control Number: 2013932661

For all general information, please contact Arcadia Publishing:
Telephone 843-853-2070
Fax 843-853-0044
E-mail sales@arcadiapublishing.com
For customer service and orders:
Toll-Free 1-888-313-2665

Visit us on the Internet at www.arcadiapublishing.com

To my daughters, Brie, Lauren, Lisa, and Evan, who received a great start on their lives here in Manhattan.

CONTENTS

ACKNOWLEDGMENTS

Manhattan, Kansas, is blessed with several rich collections of historical photographs. The largest collections are housed in the Riley County Historical Museum and in special collections in Hale Library on the campus of Kansas State University. I also drew from collections housed in the city building of Manhattan, Kansas, and the photographic collection at the Kansas State History Museum in Topeka.

There are several individuals who, without their assistance and permissions, this work would not have been possible. Linda Glasgow, curator of archives and library, and Cheryl Collins, director, at the Riley County History Museum spent hours helping me sort, note, and scan photographs and research city records. Cliff Hight, university archivist, Anthony Crawford, curator of manuscripts, and Pat Patton, librarian, in the Morse Department of Special Collections, Hale Library, Kansas State University, led me to photographs that few people had seen in decades. Gary Fees, clerk of the City of Manhattan, helped me locate city records and dust off photographic scrapbooks and helped me sort through the collections of more recent digital images. Ned Seaton, the general manager of the *Manhattan Mercury*, was exceptionally generous in providing permissions to use newspaper photographs. Stormy Kennedy and Kevin Snell, the owners of Claflin Books and Copies, arranged permissions for reproducing photographs taken from Geraldine Walton's *140 Years of Soul: A History of African-Americans in Manhattan, Kansas 1865–2005* (2008). I also received excellent assistance from Pat Michaelis, the division director of the State Archives, and Lisa Keys, periodicals and photographs assistant, both at the Kansas State History Museum in Topeka. Charles and Kay Bascom generously loaned me a family photograph of Lillian Bascom. Jana Bowman, the public relations director of Mercy Regional Health Center, graciously provided the 1961 photograph of St. Mary's Hospital. Charles Exdell's photography certainly contributed to the quality images in this book. Janet Adams, a history major at Kansas State University, and Megan Bing, a research intern at the Riley County History Museum, assisted mightily in the historical research for this volume. My deepest appreciation goes to Prof. Bonnie Lynn-Sherow, the best editor anyone could want, and, luckily for me, my colleague and the love of my life. Of course, all of these people are blameless for any mistakes made in the following pages. I managed to do those all by myself.

I want to thank two editors at Arcadia Publishing. Simone Williams was my initial contact for this project, and she guided me through the initial phases of pulling the pieces together. Williams's talent was promoted, and Jason Humphrey stepped in to steer me through the final stages of production.

INTRODUCTION

A city resembles a living body, in that its basic building blocks, its DNA, shapes the unfolding composition and development of its life. There are two persistent strands that have shaped the history of Manhattan, Kansas, from its founding. The first was Manhattan's New England heritage; the second was its Midwestern industry. Both of these predilections were aptly expressed in the town's first known sermon, delivered to a small group of hopeful parishioners on an empty lot by the Reverend Charles Blood. Praising the first non-Indian settlers to Kansas, he said, "They left their homes in the States, not singly to improve their worldly interests, but to fight the battles of freedom and save this beautiful country from the blighting curse of slavery." As a town investor himself, Blood understood firsthand that fighting for "freedom" and pursuing "worldly interests" went hand in hand.

When US Army surveyors staked out the valley that would become Manhattan, they were treading on the former homes of countless native peoples who had lived along three water courses, known today as Wildcat Creek, the Big Blue River, and Kaw River. In 1853, the Army established Fort Riley in order to regulate trade with Indians and to patrol the trails that connected the "states" to far western destinations, like Oregon and Santa Fe. Army engineers established a "military road" connecting the new outpost to Fort Leavenworth and crossing the Blue River several miles above the confluence of the Blue and Kaw Rivers. Rather than risk being washed away by the river each way, the Army awarded Samuel Dyer a contract to operate a ferry. People called it Rocky Ford.

The Army also had the unenviable task of maintaining order between the territory's opposing factions regarding the issue of slavery. The war with Mexico in 1846 extended the reach of the United States to the Pacific Coast, and both government and business sought to pull the nation together with railroad tracks and telegraph wire. Achieving this end required the creation of a new state west of Missouri and Iowa. Passage of the Kansas-Nebraska Act of 1854 permitted voters in the new territories to determine for themselves whether or not to allow slavery. Popular Sovereignty, as it was called, failed miserably, as pro-slavery sympathizers and groups of abolitionists flooded into the territory in a violent effort to shape Kansas's future.

Meanwhile, in 1854, Isaac T. Goodnow was teaching natural science in Providence, Rhode Island. He had become keenly interested in abolition and wrote his concerns to his brother-in-law, the Reverend Joseph Denison, who was preaching in Boston. They attended an inspiring speech by Eli Thayer, a founder of the New England Emigrant Aid Company, and Goodnow decided then and there to join the crusade to make Kansas Territory a free state. In 1855, he organized a migrant company; by the end of March, Goodnow was standing on the present-day site of Manhattan.

Goodnow and company were not the first to arrive in the vicinity. Samuel Dyer now called his cabin the "town" of Juniata. In early summer, George Shepard Park arrived and built a cabin just above the mouth of Wildcat Creek, and both Blood and newcomer Seth Child quickly set up housekeeping with the abolitionist Park. They named their little camp the "town" of Polistra. At nearly the same time, at the base of Bluemont Hill near the Blue River, Samuel Houston built a cabin and proclaimed it the "town" of Canton. The New England Emigrant Aid Company was supporting Houston's effort, and he was soon joined by other abolitionists, such as Elisha Thurston, the former secretary of the Maine Board of Education.

Goodnow, Park, and Houston soon realized they would benefit more by joining fortunes than competing with each other. Besides, they needed to face down the pro-slavery efforts of Dyer to promote Juniata. In April 1855, representatives of the three settlements combined to form the Boston Town Association. As Goodnow explained, "We hope to make [Boston] a N.E. [New England] Settlement of the right sort with the blessings of the Lord." In addition to being anti-slavery, these town founders embraced broad social reforms, such as women's suffrage, Prohibition, and public education.

Also in April 1855, in Cincinnati, Ohio, a group of 75 ambitious individuals gathered on the deck of the steamboat *Hartford*. Their destination was a town settlement near Fort Riley in Kansas Territory. They had chartered the Cincinnati & Kansas Land Company and were on their way west to make money and establish a town. On board was Andrew Mead, destined to become the first mayor of Manhattan; Judge John Pipher, a hard-core entrepreneur; and Amanda Arnold, a public school teacher. Judge Piper wrote of the group: "We are not rich, yet we are sober and industrious, and hope we have energy and perseverance enough to eventually build up a thriving town and an important business place." Commercialism and social idealism were about to meet.

Navigating the *Hartford* down the treacherous Missouri River, and the long wait for a spring rise on the Kansas River, taxed the patience and vim of all on board. At last, on May 20, the river rose enough to depart Kansas City. On June 1, just below the town of Boston, the *Hartford* snagged on a sandbar, was worked loose by its passengers and crew, was paddled above the mouth of the Blue River, and then again stuck fast on a sandbar, where the boat sat immovable.

Judge Pipher and Mead had earlier ventured ahead of the steamboat to locate a site for their town close to Fort Riley. Returning to the *Hartford*, they found others had already negotiated a joint venture with the Boston Town Association. On June 4, representatives of both groups agreed to the terms of a new charter, the Manhattan Town Association. As one member of the Cincinnati Town Association put it, this was "not our destination," but became "the end of our journey."

On May 14, 1857, the territorial legislature incorporated Manhattan as a city of the third class. Voters elected Andrew Mead the first mayor on May 30, and he and nine councilmen began the work of governing the city. They formed standing committees to oversee education, finances, licenses, streets and public grounds, and roads and ferries. In a county-wide election in October 1857, Ogden secured the county seat. Suspected fraud led to a recount, and it was determined that Manhattan had actually prevailed. The transition required Sheriff David Butterfield to seize the county records by force in Ogden for deposit in Manhattan, where the county commissioners held their first public meeting in December 1857.

Establishing a functional local government was just one important step in building the community. In April 1855, George Park recommended creating an "agricultural school" to secure the future of the town. Park's idea took root with Isaac Goodnow, Joseph Denison, and Washington Marlatt, all of whom articulated a similar objective. Midwestern free-soilers, like Houston and Park, along with New England abolitionists, such as Blood, Goodnow, Denison, and Marlatt, were vested in public education as a social good. More worldly individuals, like Pipher, saw the college as an economic anchor. Working together, they acquired a charter from the Kansas Legislature to incorporate the Bluemont Central College Association.

On May 10, 1859, a crowd of nearly 300 people gathered to witness the laying of the cornerstone for Bluemont Central College, located at the northwest corner of present-day Claflin and College Avenues. (A small commemorative park is there today.) By the time the college opened its doors on January 9, 1860, the 44-by-60-foot, three-story structure built of locally quarried limestone was the most substantial education facility in the state. Washington Marlatt served as its first principal, and Julia Bailey, later to become Marlatt's wife, was the school's first teacher.

When President Buchanan signed legislation making Kansas a state on January 29, 1861, town promoters jockeyed, through intrigue and manipulation, for the location of important public institutions to bolster their cities. In his meetings with state legislators, Isaac Goodnow thought he had secured Manhattan as the location of the state university. Gov. Charles Robinson, however, struck a deal cutting Manhattan out by agreeing to locate the university in Lawrence, in exchange

for putting the capital in Topeka. Goodnow had to find an alternative route for securing a public institution; in 1862, another path appeared.

Beginning in the 1840s, Congressman Justin Morrill of Vermont began calling for tracts of public land to be set aside as an endowment to fund public colleges, for educating "the sons and daughters of the industrial class." An unresponsive Congress and hostile administration, however, thwarted his efforts. The secession of the Southern states and the election of Abraham Lincoln turned the tables, and Morrill's legislation became law on July 2, 1862.

The essence of the act was that each college, "without excluding other scientific and classical studies, and including military tactics . . . teach such branches of learning as are related to agriculture and the mechanical arts . . . in order to promote the liberal and practical education of the industrial classes in the several pursuits and professions of life." To finance these new institutions, the "Land Grant" Act gave states 30,000 acres of public land for each representative and senator to establish a college. Goodnow had found the means to create a publicly funded college to serve the economic interests of Manhattan and the state.

On February 3, 1863, Kansas governor Thomas Carney signed a legislative resolution accepting the provisions of the Morrill Land Grant College Act. On February 16, 1863, the state legislature accepted the offer of the trustees to donate Bluemont College to the state for use as the nation's first operational land-grant school. Members of the Bluemont Association signed over the deed to the state on June 10, 1863. As darkness descended on July 2, the second day of the Battle of Gettysburg, troops grimly took stock of their own uncertain future and that of the nation. That same evening, a thousand miles west in Manhattan, Kansas, an enthusiastic crowd celebrated the opening of Kansas State Agricultural College (KSAC). While the fate of the nation, free or slave, united or dissolved, hung in the balance, the citizens of Manhattan were implementing a new vision of public education.

On September 2, 1863, Kansas State Agricultural College convened its first class of 26 men and 26 women. Pres. Joseph Denison heralded the arrival of "full educational privileges" for students regardless of race or gender. By June 1870, the need for an alternative farm site led to failed negotiations with the city of Manhattan. However, in 1871, voters in Manhattan Township approved a $12,000 bond issue to purchase 155 acres for KSAC. The "college farm" constitutes the main campus today. In 1872, Henry Worrall designed a plan for a campus along the lines of a "naturalistic park," and by 1875, most activities had been relocated to the new campus.

By 1880, the residents of Manhattan had secured public institutions, such as the county seat and a land-grant college. Retailers and local farmers found a ready market supplying nearby Fort Riley. The arrival of the Union Pacific Railroad in 1866 secured Manhattan's connections to Eastern markets. Social reformers continued their efforts to make Manhattan an upright and egalitarian community. The fundamental DNA was fully in place and would shape the city for another century and beyond.

Manhattanites now focused on creating a more livable city. For example, the city council actively encouraged tree planting. Trees represented civilization and acted as an oasis, shielding residents from the untamed open grasslands. Residents and city government both improved pedestrian travel with an aggressive campaign to build brick and concrete sidewalks. The need for fire protection and public health resulted in a publicly financed water system. Citizens at all levels implemented sanitation measures to clean up the city. Transportation improved, with the advent of bicycles, electric streetcars, and automobiles.

Bitter discontent among the farmer class in the 1890s led to the emergence of a third political party in Kansas, the "People's Party," or simply the "Populists." The Populist revolt created a tempest on the KSAC campus. President Fairchild was removed, and Thomas Will became a short-term Populist appointment who expanded the curriculum and provided for students' needs with a book exchange and an on-campus canteen. Progressive reformers followed in the wake of the Populists and implemented a city-commission form of government in 1912. Commissioners enacted a series of paternalistic ordinances regulating cigarette smoking, billiard halls, skating rinks, movie theaters and alcohol consumption. Citizens supported the building of a new city

hall, fire department, and public library; city park improvements; firearms control; paved streets; a municipal band; and a sewer system. New public schools were built to accommodate a rapidly growing population. The school board implemented segregated classes for elementary-age African American students and built Douglas School (an intentional misspelling of abolitionist Frederick Douglass's name) for that purpose in 1903.

World War I caused Manhattan to change in unexpected ways. A huge influx of soldiers training at Fort Riley created a chronic housing shortage in Manhattan, and the streets were suddenly filled with young men in uniform from across the nation. The local rotary club and elected officials responded with an initiative to build the Community House to provide "wholesome" recreation for soldiers. KSAC president Henry Water, the chairman of the State Council of Defense, coordinated statewide food production. The board of health, created in August 1918, was quickly tested by the Spanish flu epidemic and worked to counter the spread of venereal disease.

After World War I, Manhattanites adjusted to a rapidly changing world. They modernized their city, coped with the Great Depression, and prepared for yet another world war. In the 1920s, city growth created the need for zoning regulations to establish boundaries between business and residential uses. The first city forester, W.F. Pickett, was hired to continue the work of creating an urban forest. Commercial air transportation prompted the city commission to build a municipal airport in 1929.

A cooperative and friendly relationship benefited both city and college during these years. The college built Memorial Stadium, dedicated to KSAC students who died during World War I. The city assisted with this effort and benefited as intercollegiate sporting events became more popular. Students on campus, much to the opposition of KSAC president Jardine, began to challenge the old social order as they took to dancing, listening to jazz, and dating unchaperoned.

The Great Depression and World War II quickly revealed how sensitive the city and campus were to national and worldwide events. Rising unemployment became a serious problem for both the city and the college. Leaders resorted to a variety of New Deal programs to fund projects still extant today. World War II created conditions in the city similar to those during the previous war. Housing became scarce, and rent controls were implemented. The Community Building once again became a USO for white soldiers, while a new USO facility, the Douglass Center, was erected across the street from Douglas School for African American soldiers. In 1943, Milton Eisenhower, Gen. Dwight D. Eisenhower's youngest brother, was appointed president of his alma mater, KSAC, and began transforming the institution into a full-fledged university capable of preparing students for life in an international world.

Mayor Ross Busenbark and the chamber of commerce joined in an effort to plan for a postwar city. Housing, civil rights, and economic development all demanded innovative responses. Residents adopted a commission/manager form of government to address these concerns in April 1951. Almost immediately, the commissioners and city manager were tested by one of the worst floods in memory. More than any other single event, this disaster set the course for the future development of the city. The fast-moving waters killed 20 people, and downtown sustained immense property damage. Out of this disaster emerged a rebuilding effort that, over the next 50 years, resulted in a complete makeover of the downtown.

In the 1960 and 1970s, citizens grappled with future flood control, suburban growth, the expansion of civil rights, overseas military engagements, and environmental concerns. To keep pace with changes in the national economy, the city and university pursued knowledge-based industries and the development of a regional retail economy. The rapid growth of the university and its rising national profile under the leadership of Pres. Jon Wefald (1986–2009) sustained and stimulated the growth of the city during uncertain economic times. Given its long-standing social and economic ties to Fort Riley, the city has continued to adjust to the fluctuating effects of the 1st Division's assignments. True to its DNA, by 2012, Manhattan had become a place nationally recognized for its willingness to enhance the lives of its residents and to capitalize on its economic strengths.

One

THE KAW AND THE BLUE

PRE-1854

People have occupied the valley where the city of Manhattan, Kansas, is situated for a very long time. Research by anthropologists and archeologists suggests that humans have lived, worked, played, and died here for nearly 10,000 years. It looked much different then; a spruce forest blanketed the hills, and giant mammals, such as wooly mammoths and bison, roamed the hills.

As the climate warmed, spruce forests gradually gave way to grasslands. Humans learned to manage and sustain grassland systems through frequent fire-burning. This practice created lush savannahs that encouraged grazing animals such as bison, deer, and antelope to congregate. When these early peoples adopted agriculture, they discovered the river bottoms of the Big Blue and Kansas Rivers to be exceedingly fertile. The people built dozens of small villages and camps along the river and creek bottoms.

The hilltops overlooking the Kansas River Valley were considered sacred by Indian peoples who lived in the Kaw and Blue River Valleys prior to any contact with Europeans. American explorers stood on these same hilltops and vividly described their unimpeded view of the Wildcat Creek, Big Blue River, and Kansas River Valleys. Indian peoples' fire-burning practices had created these vistas of rolling prairie entirely devoid of trees and blanketed by grass. Here and there, a scattering of cottonwoods and a few elms, walnuts, and willows lined the stream banks.

The Kansa Indians, for whom the Kansas River and state are named, occupied the valley after the Pawnees had relocated north to the Platte River Valley. Currently, the Four Seasons Sheraton sits atop a former Pawnee site. The Kansa Blue Earth Lodge Village stood a little to the east and north of where Highway 24 now crosses the Big Blue River.

After the Louisiana Purchase in 1803, the federal government reserved the area west of Iowa and Missouri as Indian Territory. With the creation of Kansas Territory in May 1854, Indian residents of these valleys were forced out and eventually removed south to Oklahoma, where the Kaw and Pawnee Nations remain today.

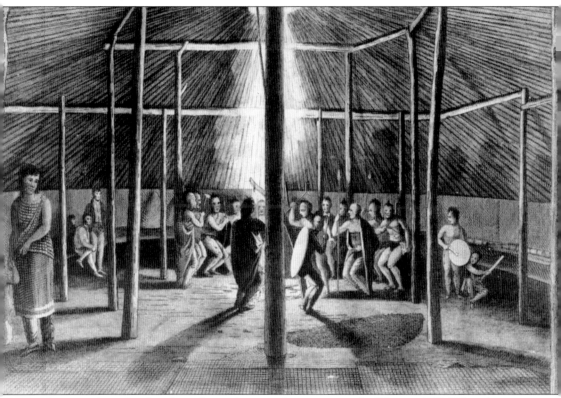

Army explorer Stephen Long began his expedition to map the West in 1819. When his troops reached the mouth of the Kaw River, he detached a small group, led by Dr. Thomas Say, to explore the valley. Say's command found the Kansa village, located near the confluence of the Big Blue and Kaw Rivers. Samuel Seymour, an artist who accompanied Say, drew a Kaw dance scene in one of the earth lodges in the village. Seymour's drawing is the first known visual account of Indian peoples living where Manhattan, Kansas, would be eventually established. (Courtesy of the Kansas State Historical Society.)

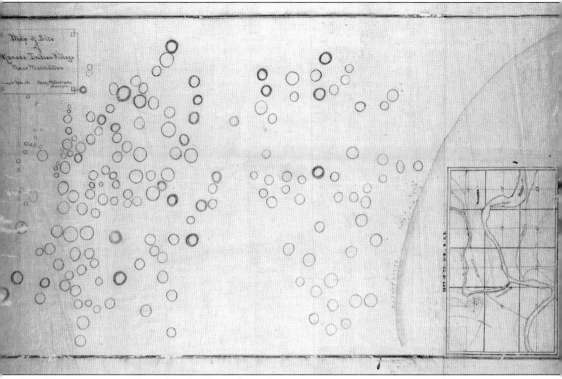

Manhattan attorney Henry Stackpole undertook a mapping assignment in 1880. The secretary of the Kansas State Historical Society had an interest in the former Kaw village near Manhattan and engaged Stackpole to locate the site and to take note of any former earth lodges that could be identified. Stackpole's original maps were thought to be lost, but in 2011, state archeologist Bob Knecht scoured the archives and found Stackpole's two original maps. The maps locate the village site in Township 10 South, Range 8 East, and identify more than 150 earth lodges. The clay soils along the river banks have a bluish tint, giving the earth-covered lodges a bluish cast. Early explorers called it the Blue Earth Lodge Village. (Courtesy of the Kansas State Historical Society.)

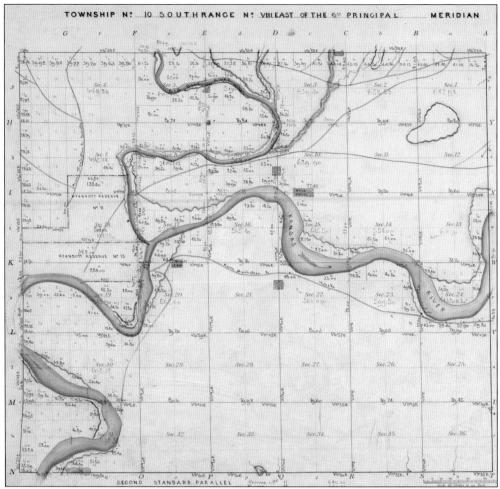

In May 1854, the surveyor general's office contracted to have the new Kansas Territory mapped. Surveyors were to note economic potential, including stands of timber, minerals, and water resources, and to divide the land into townships and sections. The map shown here, the work of surveyors George Dunn and Jarrett Todd in 1856, marked the locations of the Big Blue River and its confluence with the Kansas River. The wavy lines bordering the rivers indicate the location of trees. The land floats for the Wyandotte Nation are also shown. Floats were federally assigned lands to be sold for the benefit of the tribe. A ferry is indicated crossing the Kaw River in Section 20. The road passing through Sections 6 and 7 went north to Juniata. The hash-marked squares indicate farm fields—a scarcity in November 1856. Dunn and Todd's map reveals an open grassland where the city of Manhattan would be built. (Courtesy of the Kansas State Historical Society.)

Two

"THOSE WHO HAVE COME HITHER HAVE TURNED THE WORLD UPSIDE DOWN"
1854–1875

In April 1855, Rev. Charles Blood, a Congregationalist, gave the first sermon in Manhattan, outdoors on the lot where his parishioners were planning to build their first church. He declared that "those who have come hither have turned the world upside down." He and his wife, Mary, were among hundreds who planned, invested, and labored to realize their vision of a prosperous and egalitarian city. They sought to eliminate slavery, secure the political equality of women, curtail if not eliminate the consumption of alcohol, erect a public education system open to all, and design a "good" city graced with parks and tree-lined streets. This was an ambitious vision amid grassy hills towering above a wide, nearly treeless river bottom.

The people listening to Reverend Blood's sermon also understood that the body needed more than social reform. Charles and Mary led the way, investing in town lots and becoming instrumental in the creation of the Bluemont Central College Association and the founding of Kansas State Agricultural College in 1863. Other residents found opportunity in supplying the needs of Fort Riley or in providing financial and retail services for a rapidly growing farming and ranching population.

In May 1857, the City of Manhattan was officially incorporated. Voters elected their first mayor, Andrew Mead, and a council of nine. Through city government and volunteer groups, citizens set to work planting trees, grading streets, building commercial houses, granting right-of-ways to railroad companies, discouraging gambling and drinking, regulating firearms, prohibiting cattle from roaming at large, forming a municipal brass band, and building public works, such as a cemetery and fire station. In 1870, the city met the provisions of the state statute, making Manhattan a city of the third class, and by 1872, the regents of KSAC had relocated the main campus nearer the city center. By 1875, the social and economic foundation of the city was solidly in place.

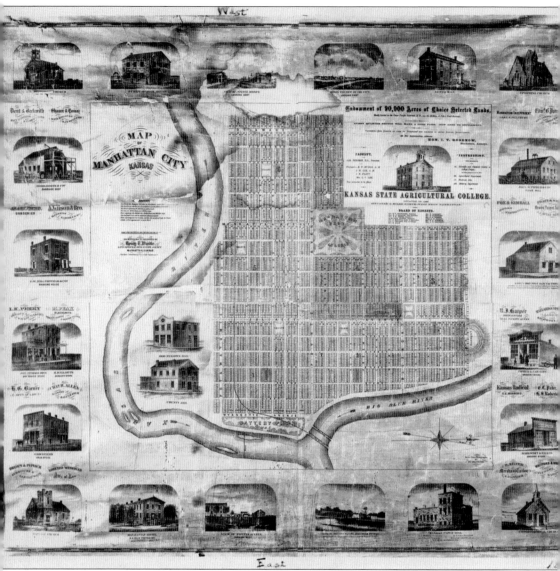

This 1867 map, designed and published by the Henry T. Wardle Real Estate Agency of Manhattan, reveals a well-planned city within a grid system. According to Samuel Houston, Army officers from Fort Riley surveyed city streets and lots in 1855, and in July of the same year, the Manhattan Town Association published the first map of the city. This 1867 map resembles the 1856 version, but it includes more elaboration and detail. All of the "avenues" were platted 100 feet wide and the "streets" 60 feet wide. In 1908, the city council approved the renumbering of the north-south streets, changing First Street to Second Street and so on, while leaving the avenues of Juliette and Manhattan unchanged. Public squares and parks are clearly shown. Public, church, and commercial buildings are illustrated around the map. Even though the actual location of Kansas State Agricultural College lay to the west of the city, the image showing the Bluemont building occupies the portion of the map called "college farm" in 1871. By 1875, this locale had become the main campus of KSAC. (Courtesy Special Collections, Hale Library, Kansas State University.)

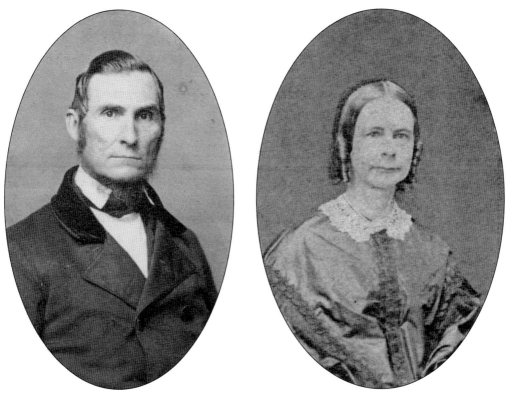

On April 22, 1855, Rev. Charles Blood delivered the first sermon in what would become the townsite of Manhattan. The American Home Missionary Society sponsored the work of he and his wife, Mary, to stop the spread of slavery. Mary was probably the first teacher in the city. The Bloods contributed to Bluemont College, and Mary wrote the lyrics to the song performed at the laying of the college cornerstone in 1859. (Courtesy Kansas State Historical Society.)

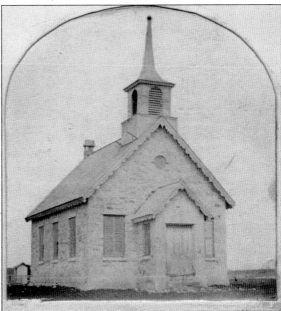

This photograph captures the simplicity of the Congregational Church before it was enlarged in 1879. In January 1856, at the home of Dr. and Mrs. Armory Hunting, a group of people organized a "democratically ruled" Congregational Church that "denounced human slavery and those who held slaves and forbade the use of alcoholic beverages." Both candidate Abraham Lincoln and Sen. Stephen Douglas contributed to the construction of the church. (Courtesy Kansas State Historical Society.)

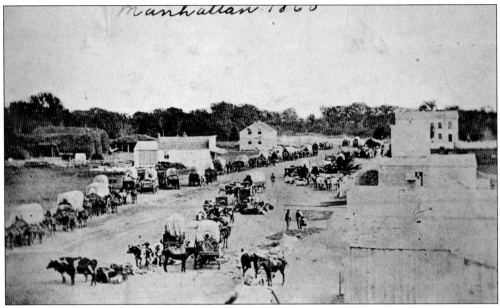

Incorrectly dated 1860, this 1863 photograph of Poyntz Avenue looking east toward the Big Blue River crossing is one of the earliest of the city. Wagon trains headed to Fort Riley, Colorado, and beyond formed a constant stream of traffic through the commercial district of this fledgling city. The three-story Manhattan Hotel stands in the background, just above the west bank of the river and its tree-lined east bank. (Courtesy of the Riley County History Museum.)

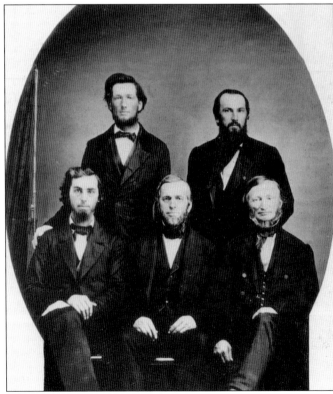

Trustees of the Bluemont Central College Association gather for a photograph. Shown here are, from left to right, (first row) Washington Marlatt, Joseph Denison, and Isaac Goodnow; (second row) Robert L. Harford and J.G. Schnebly. Goodnow served as president, and Marlatt as secretary and principal, of Bluemont College. Schnebly continued as a teacher at Kansas State Agricultural College, and Joseph Denison was appointed KSAC's first president. (Courtesy KSU Special Collections, Hale Library.)

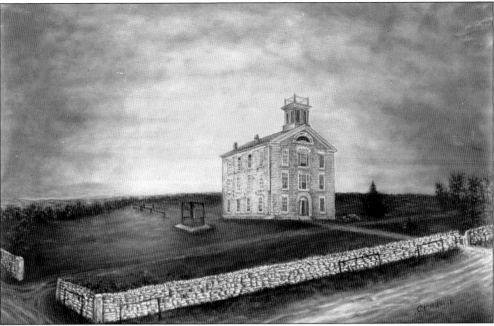

This 1867 drawing depicts the former Bluemont College building, then the site of Kansas State Agricultural College. KSAC was the first functioning institution operating under the provisions of the Morrill Land Grant College Act, 1862. (Courtesy KSU Special Collections, Hale Library.)

Shown here is the legislation enacted on February 16, 1863, that created the first functional land-grant college in the United States under the provisions of the Morrill Act. The bill is testament to Isaac Goodnow's tireless lobbying effort to get this statue passed by the legislature, and then the legislation that transformed Bluemont College into Kansas State Agricultural College, with its own board of regents, on March 3, 1863. (Courtesy KSU Special Collections, Hale Library.)

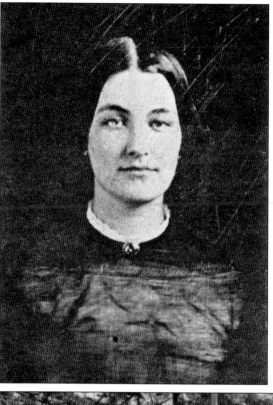

Isaac Goodnow met Julie A. Bailey (1828–1911) while teaching in Connecticut. Bailey was an educated woman by any standard, and Goodnow was impressed with her knowledge of science. Recruited by Goodnow, Bailey joined the effort to make Kansas a free state and served as Bluemont College's first teacher. She married the college principal, Washington Marlatt, in 1861. Their four children excelled academically and enjoyed distinguished careers. (Courtesy KSU Special Collections, Hale Library.)

In 1856, Washington Marlatt purchased a farm property with a small limestone house, now in the state historic register, in full view of Bluemont College. After the college building was razed in 1883, Marlatt built a barn out of the recycled roof trusses and stone. The original dressed-stone arch spelling out "Bluemont College" is now above the fireplace in the KSU Alumni Center. Today, Marlatt's farm is just south of KSU's athletic facilities. (Courtesy KSU Special Collections, Hale Library.)

Ellen Goodnow (1812–1900), wife of Issac Goodnow and the sister of Joseph Denison, had not lived long in Manhattan when she wrote that the city was "near one of the largest markets, as Fort Riley is to be the headquarters of the outposts . . . to California." The location was simply "too good for Bondage [slavery]." Ellen strongly supported the free-state movement and worked to promote KSAC and the city. (Courtesy Kansas State History Museum.)

The Goodnow House, built in 1860, is now a state historic site. Issac and Ellen could see Bluemont College from their front yard. John Currier, a carpenter from New Hampshire, built the house for the Goodnows. The architecture is distinctly New England–inspired and, not surprisingly, resembles both the Denison house and the Bluemont College building. Prof. Julius Willard took this photograph in August 1932. (Courtesy KSU Special Collections, Hale Library.)

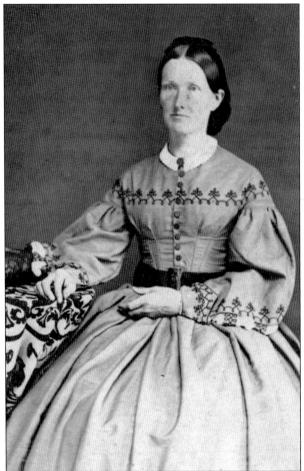

Frances Denison (1830–1908) was widowed with a young daughter at age 26. She left Missouri for Baldwin City, Kansas Territory, where she met Joseph Denison, a widower with five children. They married and raised their family in Manhattan. Frances was dedicated to supporting the college, and she worked to expand suffrage to both women and African Americans. (Courtesy KSU Special Collections, Hale Library.)

Built in 1859, the stately home of Joseph and Frances Ann Denison has been recently restored. It was built atop Hylton Heights, and the Denisons could see Bluemont College from their property. Clark W. Lewis, the stonemason who erected the Bluemont College Building, also built the Denison home. In February 1932, Prof. Julius Willard took this photograph. At the time, the house functioned as the county "poor farm." (Courtesy KSU Special Collections, Hale Library.)

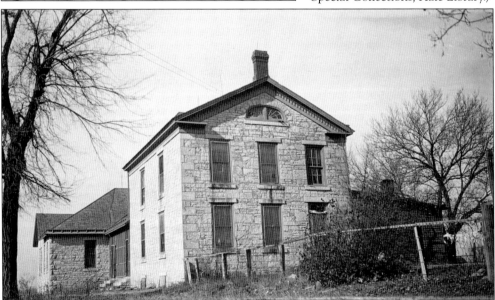

The Methodist Church at the intersection of Juliette and Pierre Streets was the first in Manhattan. The first minister was Reverend Hazelton Lovejoy. He arrived on the steamboat *Hartford* along with 17 other Methodists, and they formed the first Methodist Episcopal Church. Issac Goodnow did fundraising for the church in New England. The first service was on June 6, 1858. The Methodists sold the building to the Catholic Church in 1880. (Courtesy Riley County Historical Museum).

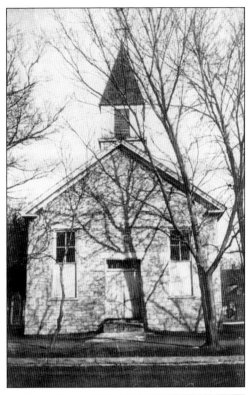

The first Catholic mass conducted in Manhattan was held in the home of Matthew Peaks in 1865. In 1881, the congregation purchased the former Methodist church. Under the leadership of Father Arthur James Luckey, the church rapidly expanded. In 1919, Henry W. Brinkman, a KSAC architecture graduate, designed a new church, now in the National Register of Historic Places. The building, seen here, was dedicated on October 31, 1920. (Courtesy Riley County History Museum.)

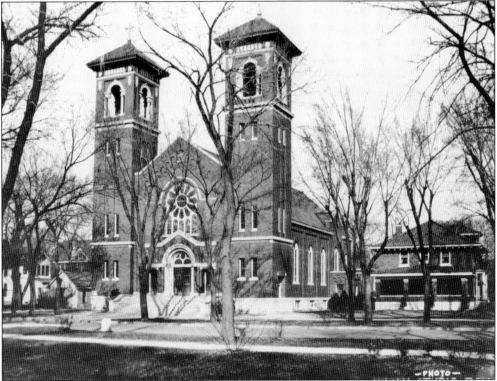

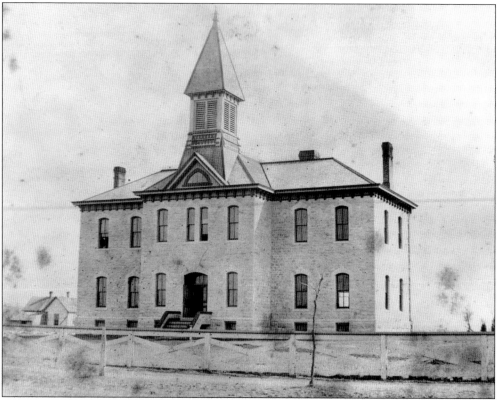

In 1857 and 1858, Levi Woodman built Avenue School, located at Ninth Street and Poyntz Avenue. A two-room, two-story building, it was one of the most substantial facilities in the state. For a few years, teachers lived on the first floor and students attended on the second. The district demolished it to build a new high school in 1882, also called Avenue School (shown here). (Courtesy Riley County History Museum.)

Amanda Arnold (1837–1923) arrived in Manhattan aboard the steamboat *Hartford* in June 1855. In 1857, she was teaching elementary school. To improve her skills, she enrolled in the first class to attend Bluemont College, in 1859. She resumed teaching in 1864 and retired in 1878. In 1985, the board of education honored her contributions to local education by naming a new elementary school for her. (Courtesy of the Riley County History Museum.)

Andrew Mead accompanied the Cincinnati Land Company and helped negotiate the deal that resulted in the Manhattan Town Association in 1855. Mead became one of the first trustees governing the newly created town. On May 30, 1857, he was elected the first mayor, along with a nine-member council. Mead left the city in 1868 and died in Yonkers, New York, in 1904. (Courtesy of the Riley County History Museum.)

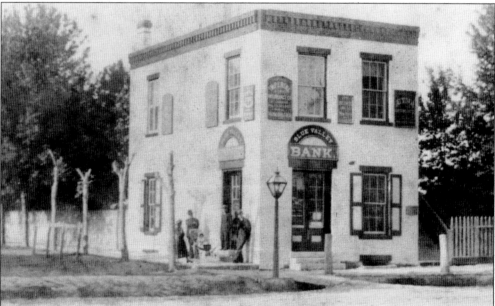

In 1855, brothers George and Uriah Higinbotham met in Manhattan and started a freighting line to Fort Riley. In 1857, their brother William joined them in real estate and retailing. In 1859, they opened the Blue Valley Bank (pictured here in 1867). Uriah died in 1865. George started his own string of businesses, but William retained the bank until economic downturns forced its reorganization as Union National Bank in 1889. (Courtesy Riley County History Museum.)

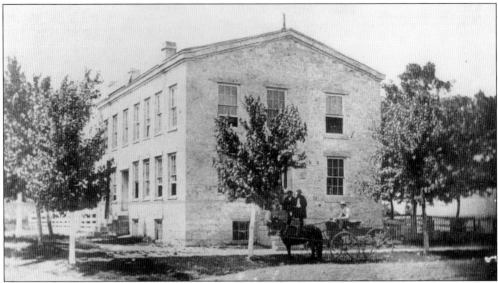

Mayor Andrew Mead owned the Manhattan House, which he had built in 1857. Considered the best hotel in the city, it remained in business until a fire destroyed it in 1870. It is seen here in 1867. (Courtesy Riley County History Museum.)

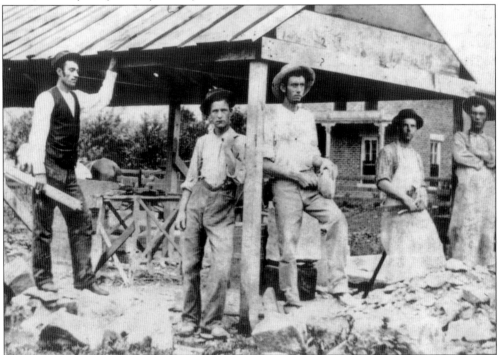

Robert Ulrich, a native of Leipsig, Germany, arrived in Manhattan in 1867. A skilled brick-maker and stonemason, he built many high-quality brick structures. By 1877, his sons, William and Edward, operated a quarry and construction company (pictured here). The Ulrichs built both public works and commercial buildings. A fine example still stands at the corner of Poyntz Avenue and Fourth Street and is appropriately named the Ulrich Building. (Courtesy Riley County History Museum.)

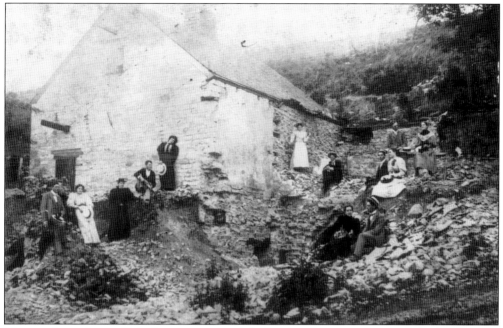

Many early residents of Manhattan supported the legal prohibition of intoxicating liquors. Not everyone did, however, as some brewed beer, ran gambling halls, and operated "houses of ill fame." The Manhattan city council had already taken action against distilleries when the state passed prohibition in 1880. This 1914 photograph shows a picnic at the ruins of a brewery that once operated in the vicinity of present-day Sunset Zoo. (Courtesy Riley County History Museum.)

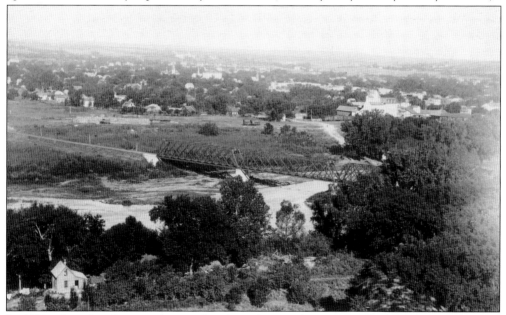

By 1890, when this photograph was taken from the top of Prospect Hill, the contours of the city were in place. Planted trees were taking root, and the city's connections to external markets can be seen in the railroad bridge spanning the Kansas River. The city limits are just beyond the tree line, where the unbroken prairie is still clearly visible. (Courtesy Riley County History Museum).

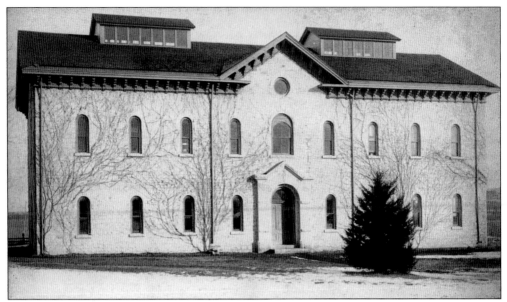

In 1871, voters in Manhattan Township passed a $12,000 bond issue to purchase land for a demonstration farm for Kansas State Agricultural College. Once the deal was sealed, the regents built a barn on the site in 1872. The barn was converted into classrooms and named Industrial Hall in 1875. Remodeled and renamed Farm Machinery Hall in 1939, it was demolished in 1963. (Courtesy KSU Special Collections, Hale Library.)

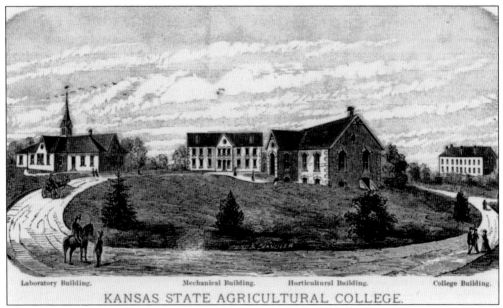

Laboratory Building. Mechanical Building. Horticultural Building. College Building.

KANSAS STATE AGRICULTURAL COLLEGE.

This 1877 lithograph shows the development of the "college farm" following Henry Worall's "naturalist park" design for the campus. The structure labeled "Mechanical Building," erected in 1875, was originally the woodwork shop; it and the laboratory building (1876) are the oldest extant buildings on the Kansas State University campus. (Courtesy KSU Special Collections, Hale Library.)

Three

MANHATTAN TAKES SHAPE
1875–1890

Manhattan residents had created a blueprint for their city and a plan for its development. By 1880, more than 2,000 people lived in Manhattan, and it became a city of the second class. The population became more diverse with the arrival of a group of "freedmen" escaping the Jim Crow South. In 1880, city government took on a new form of administration, with a mayor elected at large and a general council of two representatives elected from each of three wards. City government improved fire safety in the downtown section by limiting the construction of wooden buildings and by creating a public water system that could deliver high-pressure water to hydrants. In 1884, the city acquired lots for a new fire station, supplying it with wagons and horses. In the fourth ward, newly created in 1888, voters elected their first African American city councilman, Jerry M. Howell.

Sanitation improved after the adoption of ordinances prohibiting dead animals (mostly horses) in the streets and the regulation of slaughterhouses. The council constructed sidewalks downtown and even extended one walkway to the college campus. Public-safety improvements included prohibiting minors from owning "deadly weapons or toy weapons" and installing electrified streetlights. The council attempted to legislate morality by forbidding gambling, discouraging skating rinks, and severely limiting the sale of alcohol.

The college's president, John Anderson, who served from 1873 to 1879, unveiled a new curriculum that emphasized practical agriculture, mechanics, and domestic science. In April 1875, students began publishing the *Industrialist,* the first campus newspaper. An aggressive building campaign began with the construction of the north wing of Anderson Hall, which was completed in January 1879. KSAC's next president, George Fairchild, from 1879 to 1897, summarized the role of the college as "not so much to make men farmers as to make farmers men." He placed a high emphasis on character development along with a scientific approach to "farm, shop, and home." Under his direction, enrollment doubled from 267 in 1880 to more than 590 by 1890. The college had become a mainstay in the economy of the city.

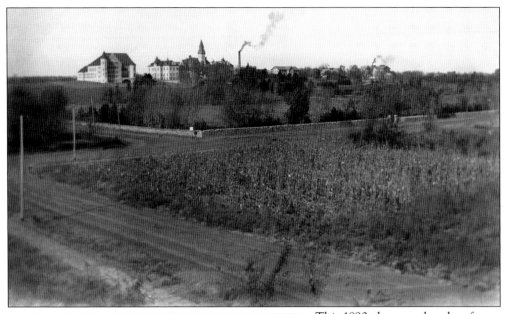

This 1890 photograph, taken from the intersection of Manhattan Avenue and Moro Street, shows the naturalistic design of the campus starting to mature. The low-standing stone wall has been constructed, with the main gate located across from Vattier Street on the east. The city graded a roadway connecting the campus to the city in 1885 and, in 1887, hooked the college up to its new water system. (Courtesy KSU Special Collections, Hale Library.)

Rev. John Anderson served as KSAC president from 1873 to 1879. He said, "the object of KSAC was a liberal and practical education" for those who would be actually engaged in agriculture, the industrial arts, and mechanical trades. All students were required to perform daily manual labor, such as feeding livestock. He resigned in 1879 after his election to the US House of Representatives. Anderson Hall was named for him in 1902. (Courtesy KSU Special Collections, Hale Library.)

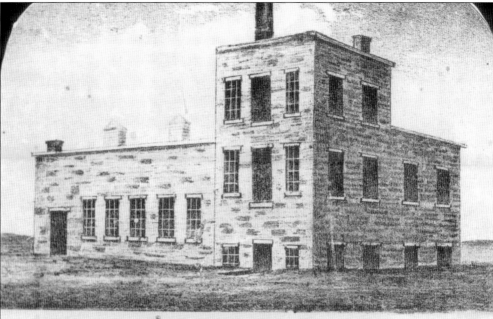

KANSAS PAPER MILL
E. C. Manning Secretary M. J. Cove, President
Edw'd Russell Treasurer Henry Laffer, Vice President
W. H. BUSH, SUPERINTENDENT

In April 1879, more than 150 former slaves fleeing oppressive conditions in the South reached the Kansas Pacific depot in Manhattan. The "Exodusters" found temporary shelter in the closed Kansas Paper Mill on Leavenworth Street. Initially building homes around the base of Bluemont Hill (near present-day Goodnow Park), they relented to white pressure to sell their land and relocated south of the Kansas Pacific Railroad tracks. (Courtesy Riley County History Museum.)

Between 1875 and 1880, the African American community grew from 100 to over 350. In October 1879, Exodusters organized the African Methodist Episcopal Church, and by April 1880, they were building a small framed house of worship at the corner of Fourth and Yuma Streets, where the current AME church is today. In 1927, church members built the new brick structure shown in this photograph. (Courtesy Kansas State History Society.)

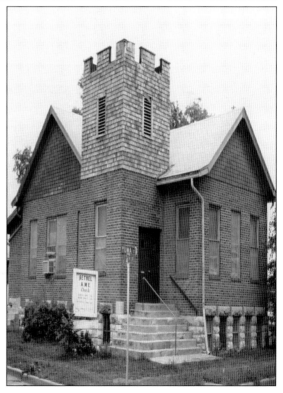

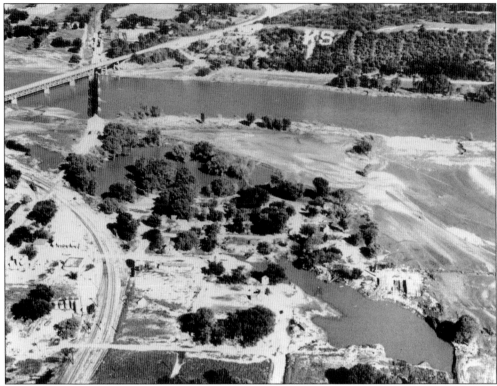

This 20th-century aerial photograph distinctly shows the part of town known as the "Bottoms." The majority of the African American community lived here, on the south side of the tracks. Each flood of the Kansas River inundated this part of town, destroying streets, yards, and homes. More-prosperous African Americans lived on Yuma Street, located a block north of the railroad tracks. (Courtesy Riley County History Museum.)

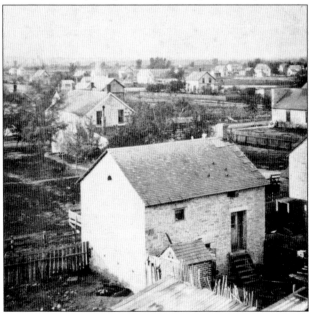

This photograph of a residential neighborhood was taken sometime before 1890. Sidewalks started becoming more commonplace in the mid-1880s. An early resident recalled that citizens kept cows in their back gardens and then turned them out to graze freely in the city after they were milked. The council took steps to prevent stray animals from wandering the streets in 1884. (Courtesy Riley County History Museum.)

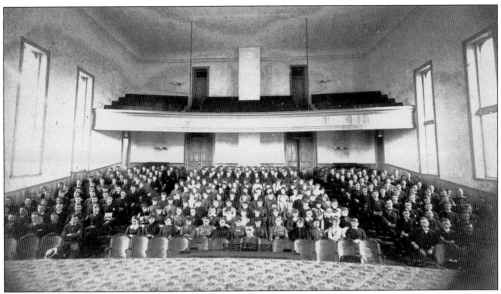

Prior to 1900, KSAC administration required students to attend daily chapel services, starting promptly at 8:30 in the morning. Unless otherwise directed by their parents, students also had to attend a "divine service" on Sunday either in the town or "elsewhere." The chapel on the second floor of Anderson Hall accommodated 650 attendees. (Courtesy KSU Special Collections, Hale Library.)

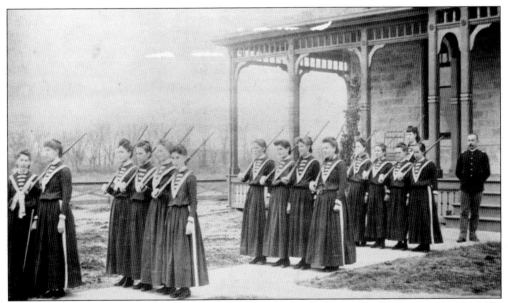

Home economics took a more rigorous scientific approach under the direction of Prof. Nellie Kedzie, who graduated from KSAC in 1876. At the time, women had few opportunities for any kind of physical activities. KSAC president George Fairchild (1879–1897) opposed mandatory military drilling; however, female students did it as a form of physical excise, as illustrated in this 1888 photograph. Fairchild approved formal "calisthenics" for women in 1892. (Courtesy Riley County History Museum.)

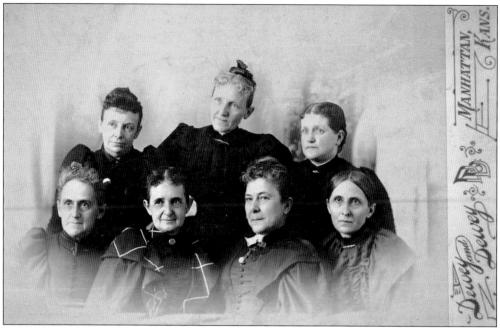

Mary E. Cripps guided the initial organization of the Manhattan Domestic Science Club (DSC) in 1880. KSAC president John A. Anderson hired Cripps to head the women's department of the college in 1875. The members of the DSC in this c. 1880 photograph were focused on improving home life. In addition to their educational mission, the membership played a civic role in promoting a public library and parks improvements. (Courtesy Riley County History Museum.)

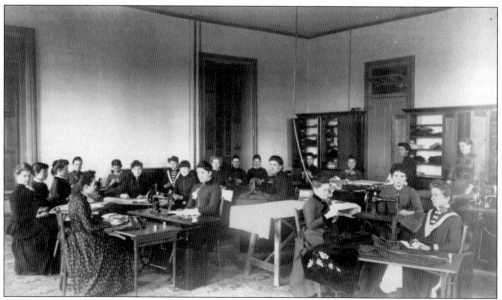

Mary Cripps's work expanded the course offerings for women attending KSAC. She, and the women who followed her, emphasized a scientific approach to "domestic" education. This included, for example, the chemistry of food preservation. Cripps oversaw coursework, such as the sewing class shown in this photograph. (Courtesy KSU Special Collections, Hale Library.)

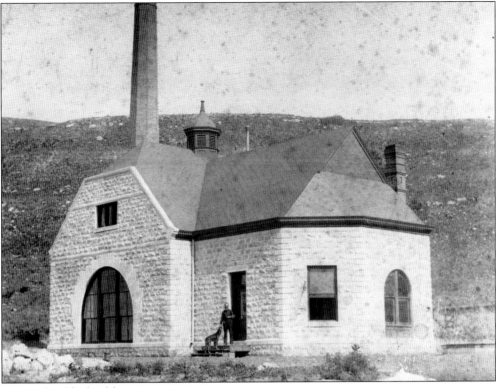

Fires and public health concerns prompted the city council to construct a public water system. In March 1887, the voters overwhelmingly approved a $50,000 bond issue to finance the project. Jubilant residents celebrated its passage with cannon fire, bonfires, and a "general hurra." The city council hired J.W. Nier to design and construct the system, then gave Nier less than four months to complete it. The map (right), from the council minute book, shows the original layout of the system. The small circles indicate fire hydrants, which were largely placed in the business district of the city. The above photograph shows the pumping plant that fed the open-air storage reservoir placed midway up the south-facing slope of Bluemont Hill. (Both, courtesy Riley County History Museum.)

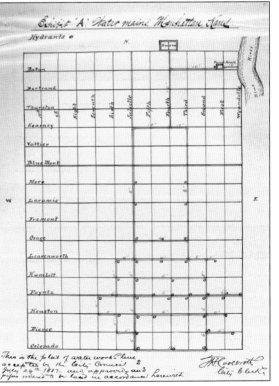

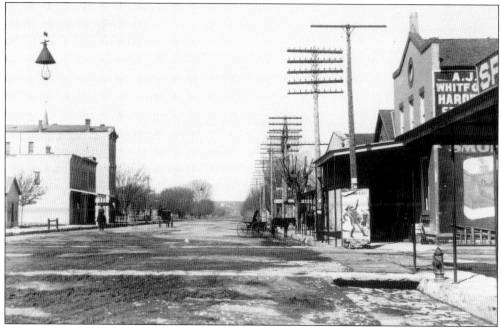

In November 1889, the city council contracted with the Manhattan Electric Light Company to install eight arc lights to illuminate certain streets until midnight. Poyntz Avenue was the first lighted street. This 1890 photograph shows the lights on Poyntz at the intersections of present-day Third and Fifth Streets. (Courtesy Riley County History Museum.)

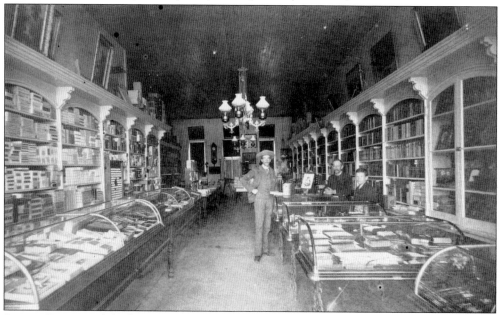

Simeon Fox opened this bookstore on Poyntz Avenue in 1866. It served as the primary bookstore for the city. In 1895, J.F. Swingle bought out Fox's interest and relocated the store to 319 Poyntz Avenue. Swingle's nephew Guy Varney later assumed sole ownership of the enterprise. In 1917, Varney sold that building and moved his bookstore closer to the college and students in Aggieville. (Courtesy Riley County History Museum.)

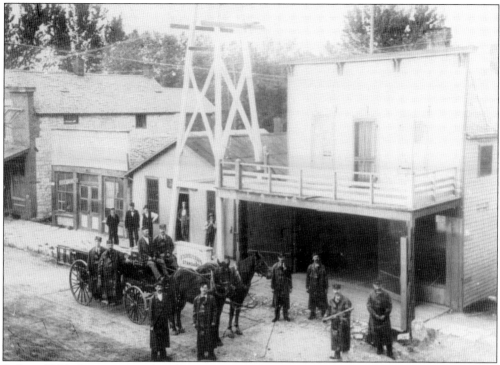

In June 1884, the city council took an important step in fire prevention by funding a fire station downtown. The council supplied the facility with a new wagon and a team of horses. In 1892, the council replaced the volunteer crew with paid staff and hired H.P. Dow as the first fire chief. Seen here, the firemen held a public exhibition drill for citizens on June 10, 1893. (Courtesy Riley County History Museum.)

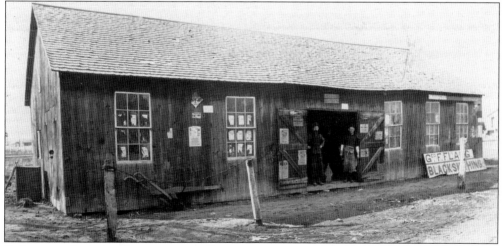

Before cars, horse stables were critically important to maintaining trade and services. This undated photograph of George F. Flagg's blacksmith shop shows an early version of this type of business. While necessary, these businesses often caused pollution, due to the concentration of manure around the premises. An 1879 study revealed organic matter and sodium chloride concentrations in "the wells in close proximity to outhouses or stables." (Courtesy Riley County History Museum.)

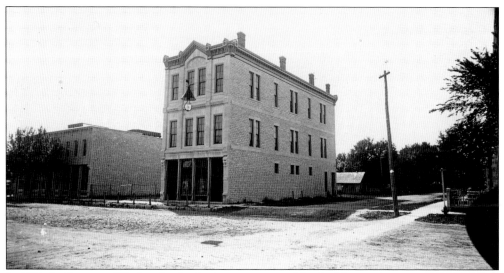

In 1883, the Patrons of Husbandry finished construction of this building at the corner of Fifth Street and Poyntz Avenue. The patrons operated a farmers' cooperative, with wholesale merchandising for its members. The cooperative failed within a year, and the building became home to the Masons and a carpenters union. Poor maintenance led the city to condemn the upper two stories, which were demolished in 1936. (Courtesy KSU Special Collections, Hale Library.)

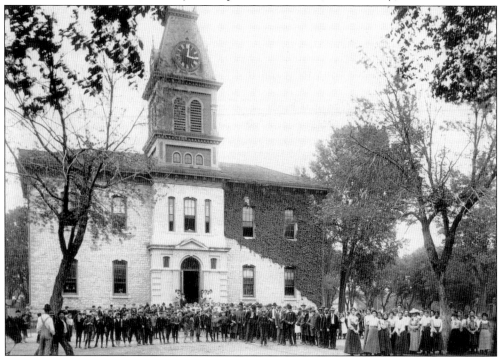

By the mid-1870s, the school-age population had far outgrown the two-room Avenue School on Poyntz Avenue. In 1878, the board of education completed a new, eight-room structure including a library with more than 4,000 volumes. Located where Woodrow Wilson Elementary is today, Central School served Manhattan until 1924. As shown in this photograph, the school was racially integrated until the opening of Douglas School in 1904. (Courtesy of Riley County History Museum.)

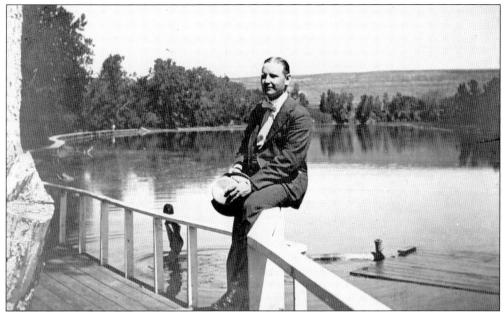

C.P. Dewey and his son Chauncey owned the largest ranch in the Manhattan area. C.P. acquired a fortune by buying and reselling city lots destroyed in the Great Chicago Fire of 1871. He invested in rangeland south of the city, and by 1910, Chauncey (above) had acquired over 10,000 acres, where he managed a cattle-finishing operation. He and his father, who died in 1904, also owned a 500-head stockyard and feedlot located next to the Union Pacific Depot. The Deweys had a ranch manager who hired the cowhands, some of whom are seen in the below photograph. The Deweys built a large stone barn and a house for the ranch hands but never erected the residence they had designed at present-day Konza Prairie. (Both, courtesy Riley County History Museum.)

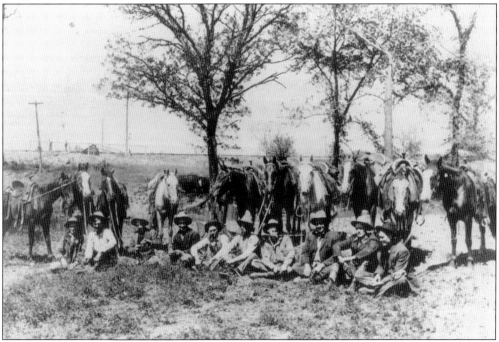

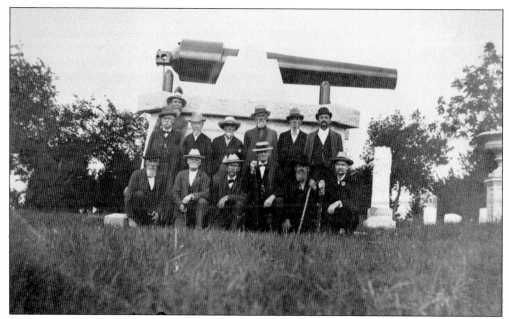

This undated photograph shows members of the Grand Army of the Republic (GAR), Union Civil War veterans, posing in front of a Civil War cannon mounted in Municipal Cemetery. In 1860, the city purchased 35 acres for a cemetery, which was renamed Sunset Cemetery in 1935. Members of the GAR were so highly regarded that the city councilmen provided plots in the cemetery for them at no cost. (Courtesy Riley County History Museum.)

The land on which City Park now stands was originally leased by the city to the county fairground association. In May 1889, the council formed an independent commission to manage the land as a park. Shortly afterward, a group of local citizens purchased a large water fountain, and the council provided $25 to offset the cost of installing it. The fountain and new landscaping can be seen in this photograph. (Courtesy Riley County History Museum.)

Four

REFORMIST ZEAL
1890–1920

Rapid economic and population growth, coupled with reformist zeal, forced numerous changes in the city and at the college. The city grew from 3,000 to nearly 8,000 persons between 1890 and 1920. Enrollment at KSAC was 590 students in 1890; by 1920, nearly 3,400 students attended classes, a six-fold increase. A new city hall, built in 1903, and county courthouse, erected in 1907, reflected the city's growing economic strength. Voters modernized city government yet again with the creation of a three-member commission in 1912.

The extreme gap between rich and poor that marked the Gilded Age prompted many Americans to embrace the idea that government must play a role in solving social problems and establishing fairness in the marketplace. Manhattanites also hoped to improve moral standards by banning billiard halls, setting curfews for youth, promoting Prohibition, and eliminating cigarette smoking. Advances in telephones, streetcars, and automobiles led to a revolution in communications and transportation. A general desire to improve the quality of city life for all initiated drives for a public library and park, and for sewer and street improvements.

Vigorous population growth required an expansion of the public school system. Voters approved construction of a new high school, junior high school, and two new elementary schools. A public debate of the pros and cons of segregated versus integrated schooling resulted in the building of a separate school, Douglas Elementary, for African American children.

The ascendency of the People's Party in the state legislature triggered one of the most contentious eras on the college campus. A Populist-dominated board of regents appointed Thomas Will, a Harvard-trained professor of economics, as president of KSAC in 1897. In 1899, the Republicans returned to power, and Will was summarily dismissed against students' protests. Will's successor, Ernest Nichols, oversaw a boom in student enrollment and implemented significant curriculum changes. By 1913, intercollegiate sporting contests had assumed an integral role on campus and gained public support when KSAC became a member of the Missouri Valley Conference.

As world war became a reality, the appearance of thousands of enlisted men being trained at Fort Riley inspired several patriotic endeavors, including the nation's first "community house" for soldier recreation. Sending so many young men off to fight in Europe was difficult enough; local residents also had to cope with the great influenza epidemic of 1918, which hit Manhattan especially hard. Upon the signing of the armistice on November 11, Manhattanites hoped the worst was over.

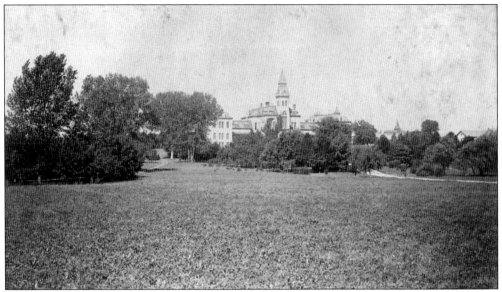

As shown in this 1892 photograph, the campus had begun taking on its current appearance. Maximilian Kern, who gained fame for his design of Forest Park in St. Louis, expanded on Worrall's original naturalistic park plan. Erasmus T. Carr, state architect of Kansas, designed College Main Building, renamed Anderson Hall in 1902. The north wing was completed in 1879, the central portion in 1882, and the south wing in 1884. (Courtesy KSU Special Collections, Hale Library.)

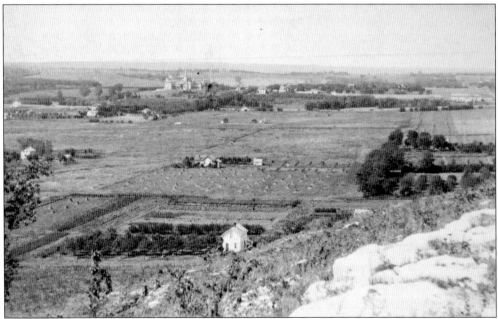

In this view looking to the west from Bluemont Hill, the campus is a treed island in the middle of an open grassland to the west and cultivated farm fields between the college and the city center. The agricultural fields directly east of the campus became Aggieville, a popular student entertainment and retail district. (Courtesy Riley County History Museum.)

Admission to KSAC was always open, without regard to race. It was not until 1899, however, that George W. Owen (1875–1950) became the first African American graduate of the school. Diploma in hand, Owen landed a position at Tuskegee Institute, where he worked with George Washington Carver and Booker T. Washington. He was a professor at Virginia State College, where he retired in 1945 as chair of the department of agriculture. (Courtesy KSU Special Collections, Hale Library.)

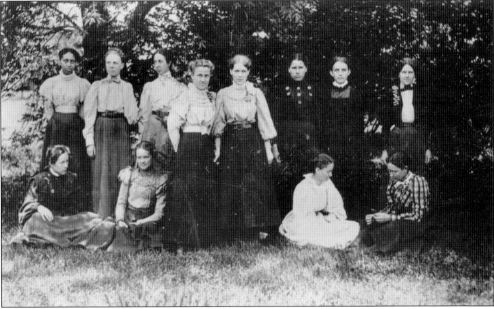

Minnie Howell (1878–1948), believed to be the woman in the second row, far left, was the first African American woman to graduate from KSAC, in 1901. She began her teaching career at the Topeka Industrial Institute and, from 1931 to 1938, was head of the Home Economics Department at the Negro A&M College in Louisiana. She retired to Manhattan and became the director of the Douglass Center in January 1946. (Courtesy KSU Special Collections, Hale Library.)

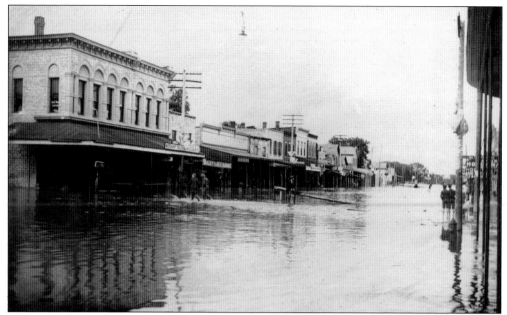

On Friday, May 29, 1903, the Kansas River began to rise. By Saturday, more than 1,000 residents had fled downtown. In places along Poyntz Avenue, the water was more than five feet deep. Most flood victims found refuge on the KSAC campus; around 100 African Americans, the hardest hit group, were sheltered in Avenue School. On Tuesday, residents returned to their homes and businesses and began the painful cleanup. (Courtesy Riley County History Museum.)

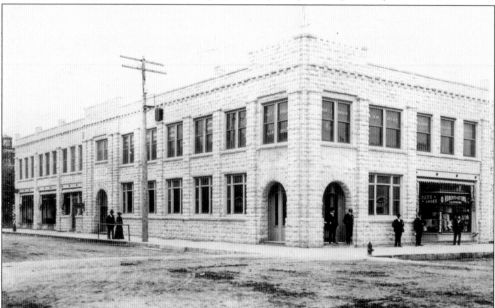

Union National Bank demolished the old Blue Valley Bank building at Poyntz Avenue and Fourth Street to make way for a new structure. This photograph shows the new bank shortly after it was finished in 1905. Bank president J.B. Floersch directed a highly respected and successful financial institution. The Floersch family guided the bank well into the 1930s. (Courtesy Riley County History Museum.)

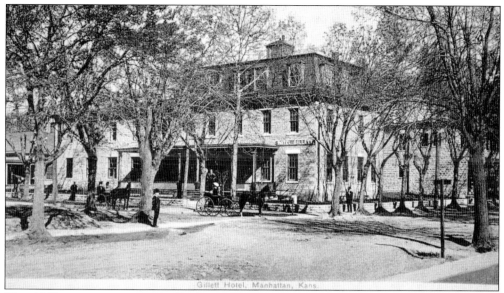

This 1868 structure was originally the home of William and Caroline Higinbotham. When William's banking investments failed in 1889, Caroline turned their substantial downtown home into a hotel and rented out rooms for $2 a night. Caroline sold the house in 1899 to Rube Gillette, who renamed it the Gillette Hotel. The building was enlarged twice; by 1945, the hotel had 96 rooms and other accommodations. (Courtesy Riley County History Museum.)

In the 19th century, doctors visited patients at home. During epidemics, such as the 1865 smallpox outbreak, public schools housed the sick. In 1903, C.P. Dewey built a small wooden hospital at the corner of Fremont and Eleventh Streets. Pictured here in 1907, the building overlooked City Park, hence the name Parkview Hospital. The hospital later moved to Juliette Avenue and Moro Street, but the name "Parkview" remained with the building. (Courtesy Riley County History Museum.)

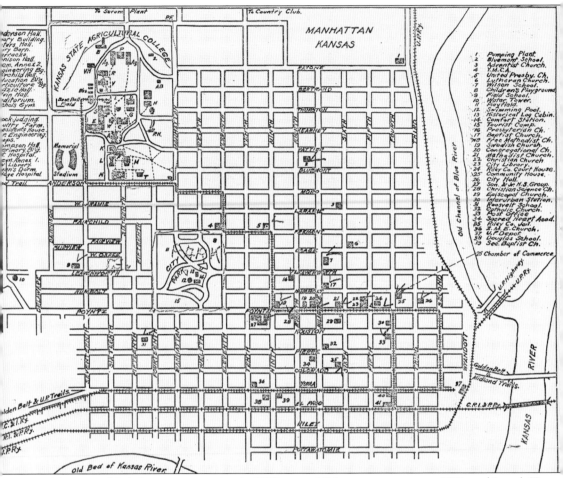

After several failed attempts, starting in 1885, to establish a streetcar system, W.R. and Joseph T. West managed to secure a franchise from the city council in September 1908. This map shows the location of the first route, known as the Avenue Route, built by the Manhattan City and Interurban Railway Company. A second line, called the Fourth Street Route, was completed in October 1909. The franchise set fares at 5¢ per ride and required the company to provide transfer tickets. Children under the age of five were allowed to ride for free, as were policemen, firemen, and postal carriers. The company was required to run cars from 6:00 a.m. to 11:00 p.m. each weekday. The company ended operations in 1928, as cars became commonplace. (Courtesy Riley County History Museum.)

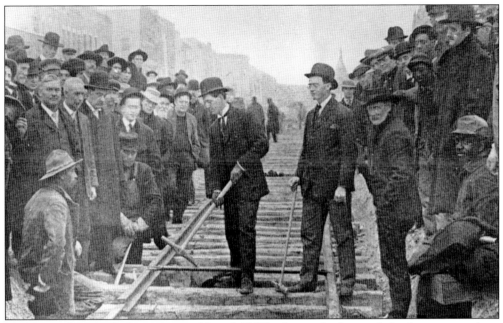

The above photograph shows W.R. and Joseph T. West laying the first track for their streetcar line, the Manhattan City and Interurban Railway Company. Construction of the rails began in November 1908, and on June 10, 1909, amid city celebrations, the cars started down the tracks connecting the downtown to the KSAC campus. The company operated a total of six truck motorcars and four trailers on four and a half miles of track, with cars running every 20 minutes. The 1913 photograph below, taken in winter, shows a streetcar headed east on the Fourth Street route along Vattier Street. Bluemont School stands in the upper right portion of the photograph. (Above, courtesy KSU Special Collections, Hale Library; below, courtesy Riley County History Museum.)

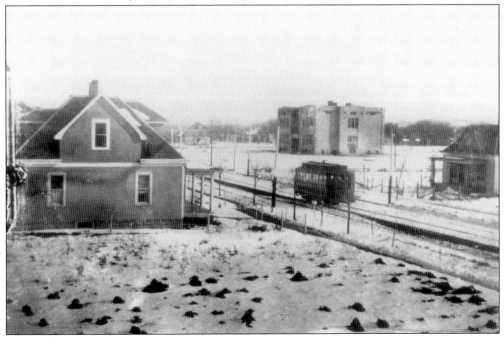

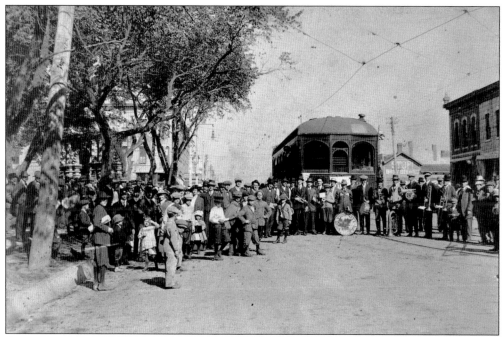

Congress permitted W.R. and Joseph West to build streetcar lines on Fort Riley to connect with a line originating in Junction City. The Wests then asked Manhattan voters to approve a bond issue of $20,000 for an interurban line connecting Manhattan to Fort Riley and Junction City. Approval came in October 1910. This photograph shows the first train to reach Junction City from Manhattan, on October 14, 1914. (Courtesy Riley County History Museum.)

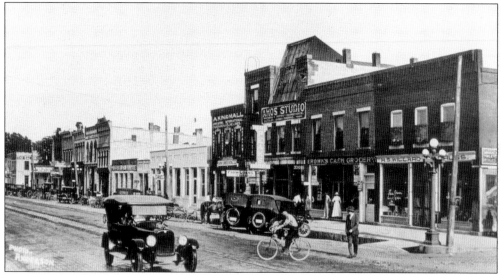

At the turn of the 20th century, city government coped with regulating several different kinds of transportation. This c. 1918 photograph shows pedestrians, bicyclists, automobiles, horse-drawn carriages, and streetcar rails all congregating on Poyntz Avenue. The first ordinance for regulating bicycles was passed in 1896, followed by automobile registration and licensing in 1909. The city prohibited cattle and swine from being driven along streets or alleys in 1911. (Courtesy Riley County History Museum.)

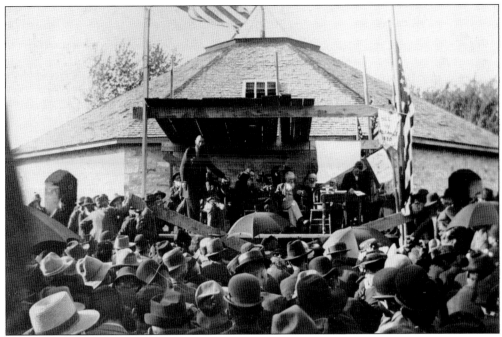

The Populist uprising in the 1890s had deeper support statewide than in Manhattan. A Populist majority on the board of regents required KSAC to provide lectures in "economics" so that the "agricultural classes . . . understand the economic laws which underlie all civilization." This photograph shows US senator William Peffer (served 1893–1899), a Populist, instructing a crowd in City Park that "the public good is paramount to private interests." (Courtesy KSU Special Collections, Hale Library.)

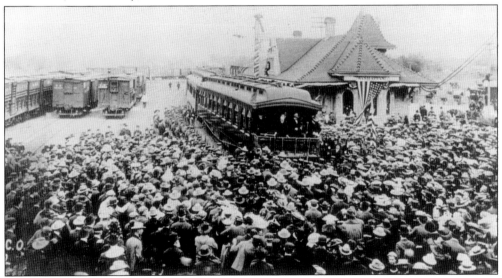

Manhattanites embraced their own version of "progressive" reform in the early 1900s. Pres. Theodore Roosevelt symbolized a moderate platform, so, when he made a train stop in Manhattan on May 2, 1903, a large and enthusiastic crowd greeted him at the Union Pacific depot. Businesses closed, bands played, and students were let out of classes to hear the president give a rousing 18-minute speech. (Courtesy Riley County History Museum.)

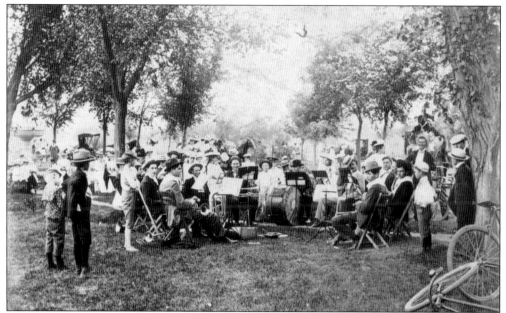

Manhattan enjoyed a brass band that gave outdoor concerts as early as 1870. This 1900 photograph shows a full-fledged band in City Park. The public first sought city funding for the band in 1871. In 1919, the council allowed a public referendum that provided funding for the band. In March 1920, B.H. Ozment became the first paid director of the Municipal Band. (Courtesy Riley County History Museum.)

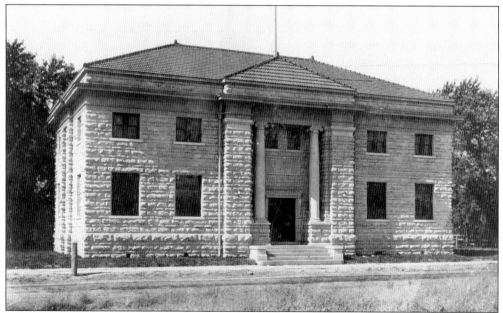

Manhattan's Library Association started in 1857. In 1903, association members saw an opportunity to build a public library by eliciting support from the Carnegie Corporation Library Building Program. Voters strongly approved funding for a "free library" in April 1903. That month, the council appointed directors to work in conjunction with the Carnegie Corporation to oversee the project. The library was completed in 1904. (Courtesy Riley County History Museum.)

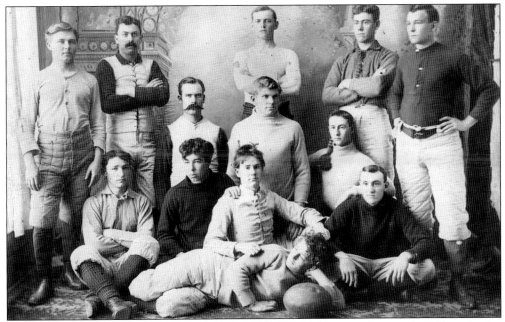

In 1887, football matches on campus were held between students and townies. College faculty controlled sporting events, so it was not until 1894, when this photograph was taken, that the KSAC team was permitted to play off campus. In 1897, A.W. Ehrsam became the first paid coach. In 1906, KSAC beat Kansas University before a crowd of 1,500 people. Celebrants filled Manhattan streets, lit bonfires, and rang the college bell. (Courtesy KSU Special Collections, Hale Library.)

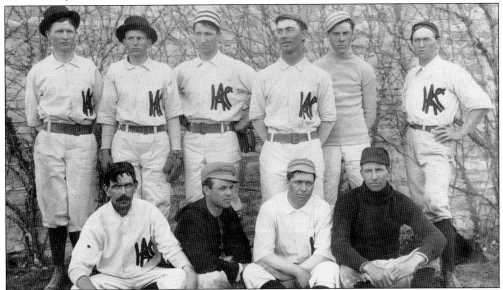

Students played baseball at KSAC as early as 1866. The first teams were composed of both townsmen and students until 1898. The faculty authorized the first out-of-town game in 1894. KSAC built a field, where Bluemont School is today, in 1897, the same year as this photograph. In 1899, the faculty allowed intercollegiate competition, and in 1906, Mike Ahearn began his legendary coaching career. (Courtesy KSU Special Collections, Hale Library.)

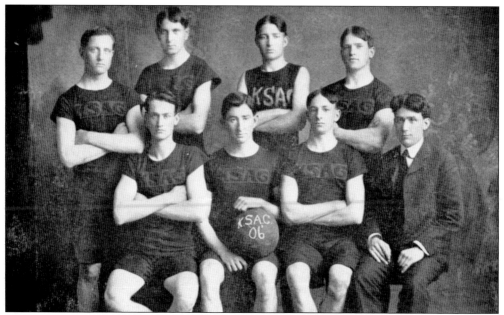

KSAC men played their first game of basketball in November 1901 in the stock judging room of the college barn. In its first intercollegiate game against Haskell Indian Boarding School, KSAC lost 60-7. In 1906, when this photograph was taken, the Manhattan Commercial Club was providing use of its hall for practice and games. Nichols Gym became the first on-campus court in 1911. (Courtesy KSU Special Collections, Hale Library.)

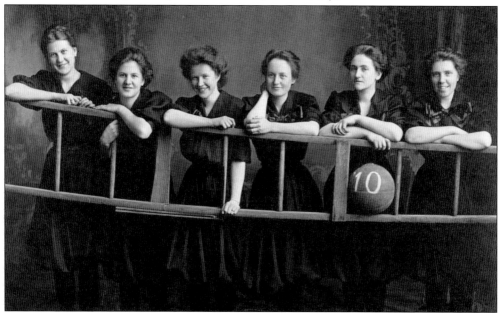

In the spring of 1901, before 500 enthusiastic spectators, KSAC women played their first game of basketball on an open-air campus court. Afterward, the faculty ruled that women play in their gym in Holtz Hall and games be viewed only by "immediate friends and relatives." In 1902, the women asked permission to play intercollegiate games, which the faculty denied in a "close vote." This 1910 team played intramural games. (Courtesy KSU Special Collections, Hale Library.)

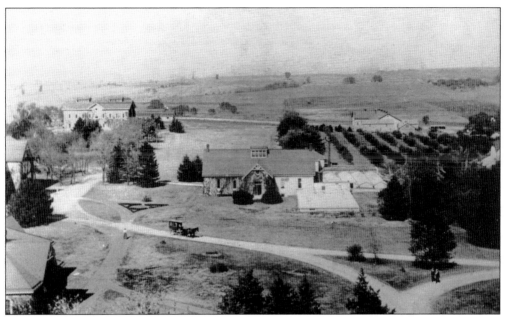

This 1890 view of campus from atop Anderson Hall reveals the extent of the applied agriculture curriculum; in the center of this photograph stands Horticulture Hall. The Hatch Act of 1887 funded faculty research experiments in the greenhouse and fields to the right of the building. The 1875 stone barn, in the upper left corner, was by this time converted to classrooms and called Farm Machinery Hall.

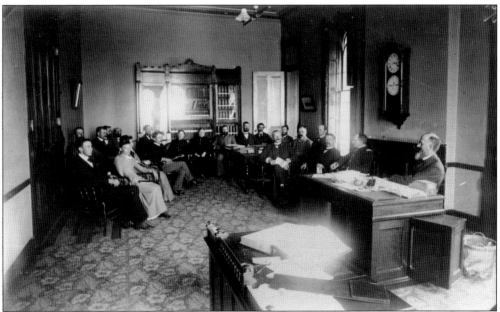

KSAC president George Fairchild (served 1879–1897) held weekly faculty meetings in his office, as recorded in this 1892 photograph. Formerly the vice president of Michigan State Agricultural College, KSAC's third president strongly believed in applied education. According to Fairchild, a well-educated person finds pleasure in life because "all things do him good not so much because he owns them as because he understands them."

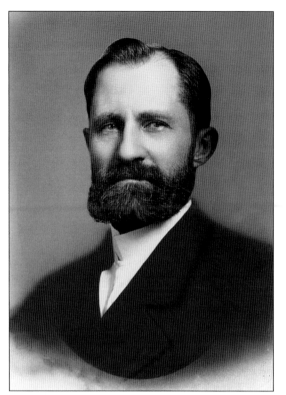

Populist-appointed KSAC president Thomas Will (served 1897–1899) was a Harvard graduate in economics. He was a "students'" president who initiated a cooperative bookstore that sold texts and supplies at "cost and expenses." The store was "warmly approved" by students and "warmly disapproved" by city bookstore owners. Will opened a dining facility for students, was an avid bicyclist, and held student socials at his home. (Courtesy KSU Special Collections, Hale Library.)

In this 1898 photograph, President Will (first row, center) poses with his faculty, half of whom he appointed in 1897. One faculty member, Mary F. Winston, was the first woman with a doctorate to teach at KSAC. Four of Will's appointees held doctorates, a fourfold increase over the single doctorate holder in 1896. Several new faculty were indeed social reformers, or at least sympathetic to various reform movements. (Courtesy KSU Special Collections, Hale Library.)

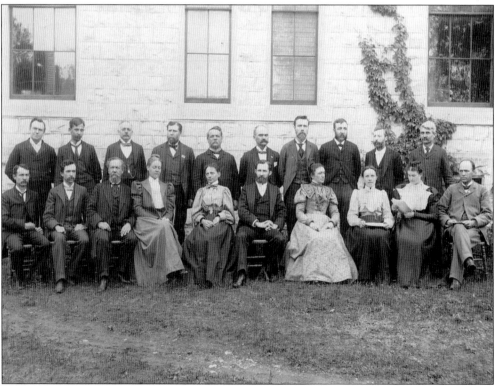

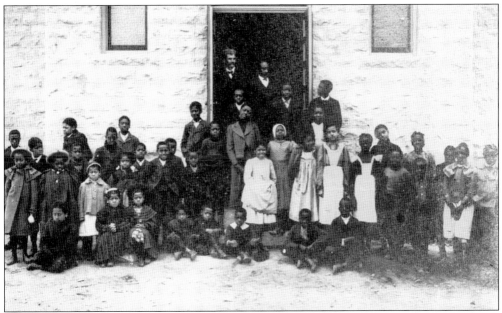

Elementary schools in Manhattan were integrated until 1884, when Avenue School segregated black and white children into separate classrooms. In 1901, a public debate arose over building a separate school for African American children. In 1903, the school board voted to build Douglas School for African American children, hiring Eli C. Freeman, a proponent of separate schooling. (Courtesy Riley County Historic Museum.)

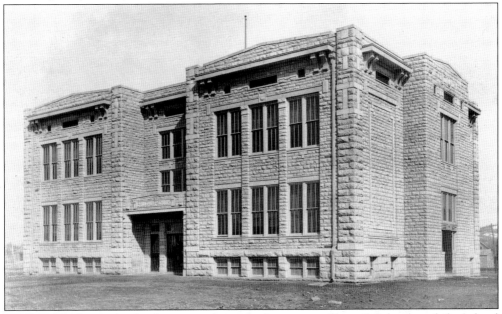

By 1911, Manhattan's school-age population had outgrown Central School, and the school board voted to build a new, state-of-the-art elementary school. H.B. Winter, KSAC graduate in architecture, designed the building, and construction of new Bluemont School started in 1911. The white children of Manhattan began classes there in January 1912. (Courtesy Riley County History Museum.)

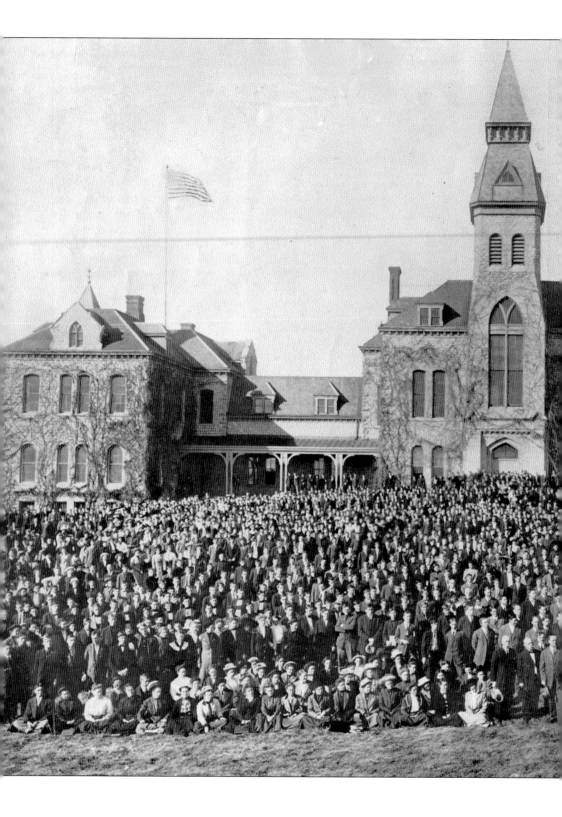

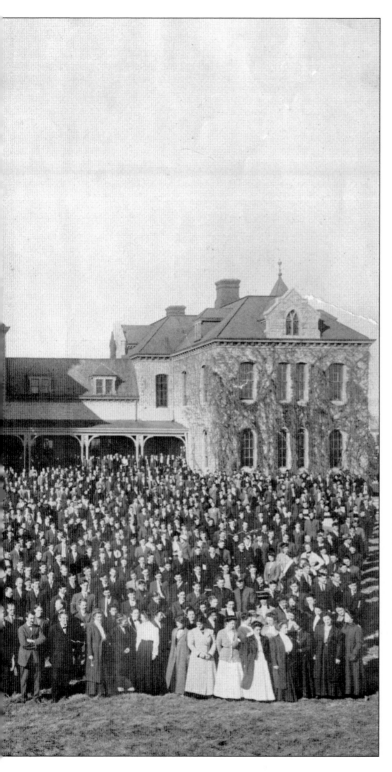

This photograph shows the rapid growth of KSAC after 1900. Pictured here are the 2,400 students enrolled in the 1910–1911 class. KSAC president Henry Jackson Waters (served 1909–1917) had a flair for spectacle, as revealed in his elaborate inauguration followed by a reception for more than 800 guests. Under Waters's administration, a high school degree or its equivalence was now required to enroll. The faculty adopted a two-semester calendar and began recording student grades with a letter system. Waters also implemented a sabbatical leave policy for faculty and appointed the first academic deans to oversee four divisions in the growing "courses" of agriculture, general science, mechanical arts, and home economics. (Courtesy KSU Special Collections, Hale Library.)

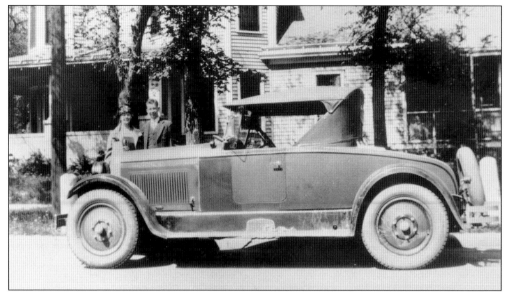

Edward Houghton, pictured here with his mother, proudly shows off his 1920 Nash Roadster. Houghton benefited from the Commercial Club's promotion of "good roads." An increase in car ownership led to safety concerns about drivers "speeding" through the city. In 1907, the city regulated how fast Edward could drive—10 miles per hour in the business district and 12 miles per hour in residential neighborhoods. (Courtesy Riley County History Museum.)

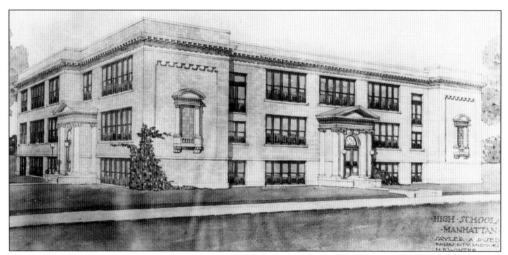

Until 1912, Manhattan supported a two-year high school and relied upon the college in preparation for postsecondary work. After KSAC raised its entrance requirements to a high school degree, voters approved a bond issue of $90,000 to build a new high school. The issue passed in January 1913, and Henry Winter designed Lincoln High School on the former site of Avenue School. The first class entered in 1914. (Courtesy Riley County History Museum.)

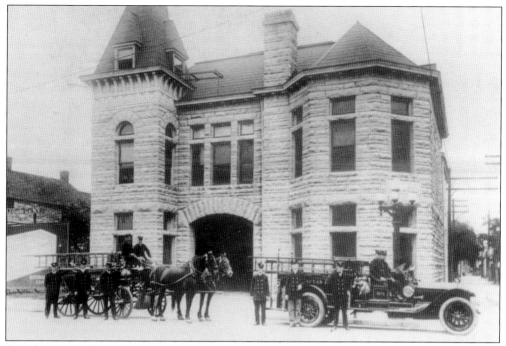

Swiss born and educated, Prof. John D. Walters began teaching architecture at KSAC in 1877. Well regarded locally, Walters was hired by the city council to design a new city hall and fire station (pictured here in 1914). The voters approved the building in 1902, and contractors finished their work in 1903. In 1909, sleeping arrangements for full-time firemen were made for the first time. (Courtesy Riley County History Museum.)

Before 1905, a main-floor jail and second-floor courtroom functioned as county offices on the "Court House Square" between Pierre and Colorado Streets. In 1903, voters approved a new courthouse, but it was Adelia Higinbotham who determined its location on Poyntz Avenue by donating several lots for that purpose. Topeka architects J.C. Holland and Frank C. Squires designed the Romanesque building, completed in 1907. (Courtesy Riley County History Museum.)

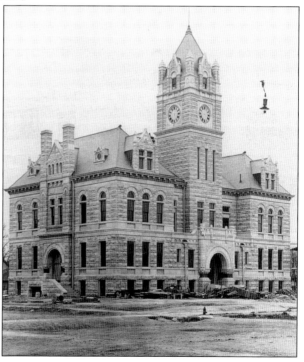

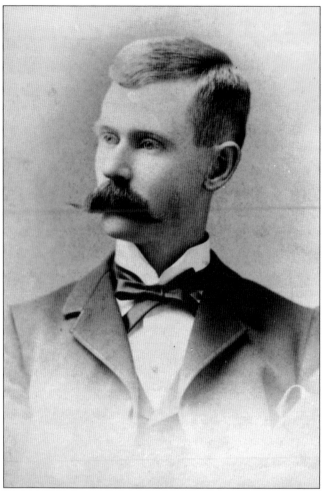

Harry P. Wareham (1866–1939) was an early entrepreneur in Manhattan. His father owned a mercantile on Second Street and Poyntz Avenue until his untimely death in 1875, when Harry was only nine years old. At 18, Wareham opened a skating rink, which self-righteous citizens considered "undignified." Wareham had a knack for providing public entertainment; in 1893, he bought Moore's Opera House, changing it to Wareham's Electric Theatre in 1895. Wareham also provided staged entertainment in the "Air Dome" (below). He built the first telephone system in 1894, the first city sewer system in 1899, and the Wareham Hotel in 1926 on the former site of the Air Dome. The business community recognized his abilities and elected him the first president of the Manhattan Commercial Club (precursor to the chamber of commerce) in 1900. (Both, courtesy Riley County History Museum.)

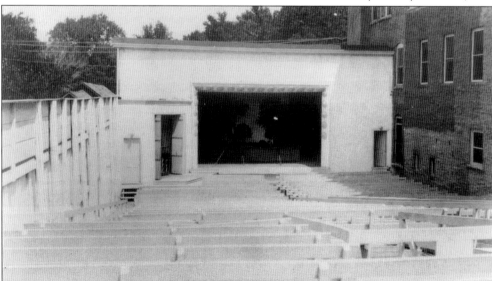

In 1910, Wareham's theater, shown right in 1913, became second in the state to feature motion pictures. Many residents questioned the moral values depicted in movies and other forms of popular entertainment. Professors and ministers also spoke out against billiard halls and skating rinks, shutting them down in 1911 and 1912, respectively. "Blue Laws" prohibited sporting events on Sundays. (Courtesy Riley County History Museum.)

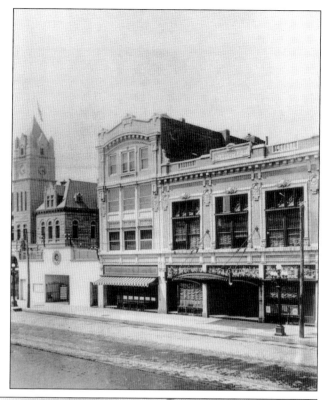

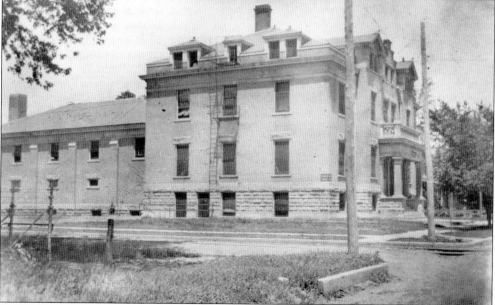

The Young Men's Christian Association and the Young Women's Christian Association once had a strong KSAC presence. In 1907, the YMCA contracted with J.C. Holland, a Topeka architect, to build the facility seen here. In April 1926, the YMCA sold the building to Parkview Hospital. In 1946, the Sisters of St. Joseph purchased the building and managed it as a maternity hospital. It houses a fraternity today. (Courtesy Riley County History Museum.)

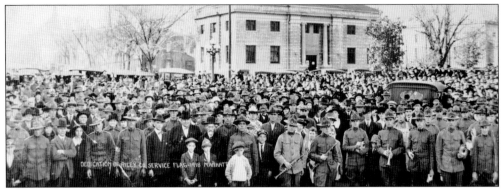

Manhattanites actively supported the United States during World War I. This photograph shows a patriotic crowd gathered for the dedication of the Riley County Service Flag in 1918. War bonds, Red Cross drives, patriotic speeches, and calls to service characterized daily life. In June 1919, the city gave a huge welcome home parade for Company I, 5th Division, "Manhattan's Own Boys." (Courtesy Riley County History Museum.)

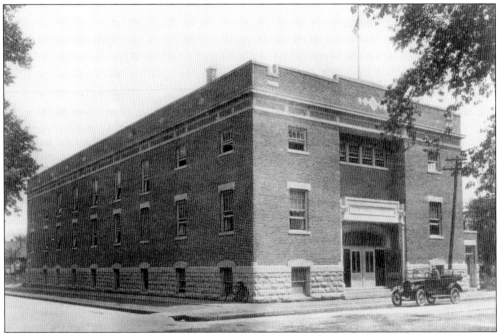

In November 1917, the Manhattan Rotary received $16,000 in funding from the Eleventh District of the club to build the Community House. Voters matched this amount with a $15,000 bond to build this soldier comfort station at the corner of Fourth and Humboldt Streets. Designed by H.B. Winters and dedicated in June 1918, it became a center for soldier recreation and support services within the city. (Courtesy Riley County History Museum.)

Five

REACTION, DEPRESSION, AND WAR
1920–1950

Manhattan was deeply affected by the social and technological changes of the first two decades of the 20th century and, as a result, was somewhat reactionary following the war. Some residents supported the Ku Klux Klan and its supposed platform of "100% American" values. KSAC president Jardine and the dean of women, Mary Van Zile, tried unsuccessfully to stop students dancing the Charleston and listening to jazz. The city commission debated allowing funerals or motion pictures on Sundays; it closely regulated jukeboxes, fireworks, and dance halls. African Americans began asking for better living conditions. Commissioners responded to technological change by adapting streets for automobiles and by acquiring the airport property. In 1924, KSAC became one of the first colleges in the nation to broadcast music and sporting events over the radio. By 1923, big-time intercollegiate football was being played in the new Memorial Stadium.

As the Great Depression made clear, however, the city was not immune to national economic trends. In 1932, Mayor Evan Griffith estimated that among the 12,000 city residents, over 1,200 were destitute. New Deal programs to alleviate unemployment helped many city residents. The commission applied for more than 30 Works Progress Administration projects, most of which were funded. The Public Works Administration built a new swimming pool in City Park in 1939, and the National Youth Administration engaged 2,289 KSAC students. New Deal programs also funded art and building projects on campus.

Enormous federal investment at Fort Riley ended the area's economic hard times. Nonetheless, the war created hardships of its own. Families again endured the loss of sons, fathers, and brothers. A housing shortage led to federally imposed rent controls. Postwar leaders, understanding that the city and college were on the threshold of a new era, formed a committee to plan for future development in the city. The school board and city both addressed integration. The sudden enrollment of hundreds of veterans under the provisions of the GI Bill dramatically transformed the student body at the college. Under the leadership of KSC president Milton Eisenhower (served 1943–1950), the college expanded its curriculum and focus in order to play a role in international development.

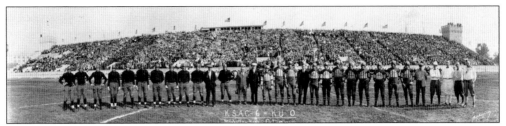

The college lost 43 students and 1 faculty member in the war. Shortly after its end, people began fundraising to build a new football stadium to commemorate those who had died. City government sent a representative to the board of directors of the KSAC Memorial Stadium Corporation. This 1924 photograph shows the KSAC football team after defeating KU 6-0. (Courtesy KSU Special Collections, Hale Library.)

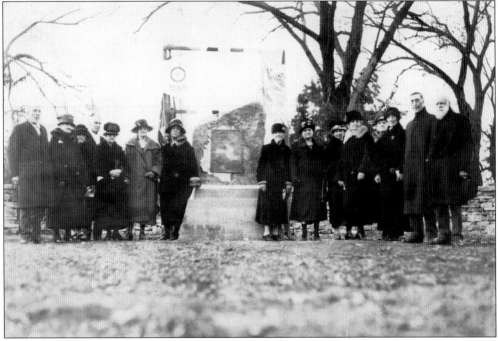

On November 26, 1926, an esteemed group gathered for the Bluemont College Site Memorial dedication ceremony. The Riley County Historical Society and the local chapter of the DAR hosted the event, and KSAC president Farrell (served 1925–1943) gave the address. Abby Marlatt, 12, granddaughter of Washington and Julia Marlatt, unveiled a commemorative marker attached to a two-ton glacier stone found in Pottawatomie County. The monument still stands today. (Courtesy KSU Special Collections, Hale Library.)

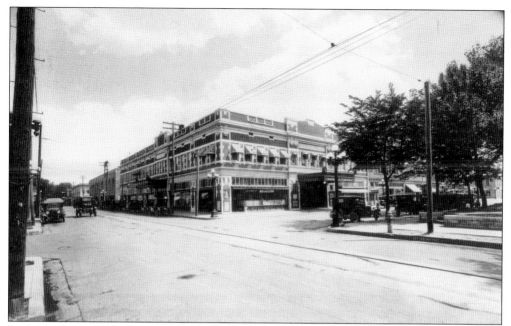

By 1920, Marshall Theater, together with the Wareham, dominated the motion-picture business in Manhattan. Henry Marshall and his son Jesse built their theater in 1908. When it opened on December 6, 1909, the auditorium could seat more than 1,000 people. The Marshalls provided office space on the second floor and some main-floor retail. Built of brick, the building was a sharp departure from the historic limestone downtown. (Courtesy Riley County History Museum.)

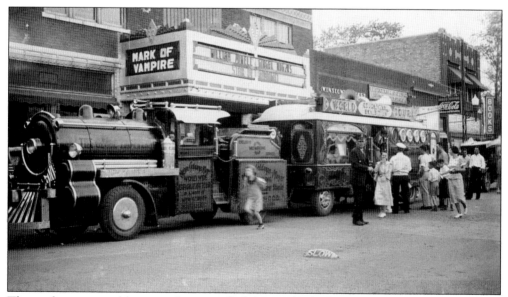

The student-centered business district called Aggieville had grown considerably in its retail and entertainment offerings by 1930. The Varsity Theater, pictured here, was showing *Mark of the Vampire* in 1935. Theater owners chaffed at having to close on Sundays. In 1934, the city commission put the issue to a public referendum, resulting in a decisive vote approving Sunday viewings. (Courtesy Riley County History Museum.)

The city's economy included businesses tied to the surrounding agricultural production. The Perry Packing Company, shown above in 1929, was the largest downtown employer, with 755 people. Amos and John Perry opened their packing company in 1888, and in 1913, John built this brick facility. In 1935, he enlarged the plant, which specialized in eggs, poultry hatchery, and frozen food lockers. The below photograph, taken in 1920, shows a downtown bakery owned by Will Gore (seated) and his sister Maggie. Earl Fitzgerald (standing) was one of the employees. The dough mixer is the gear-driven machine on the right. (Both, courtesy Riley County History Museum.)

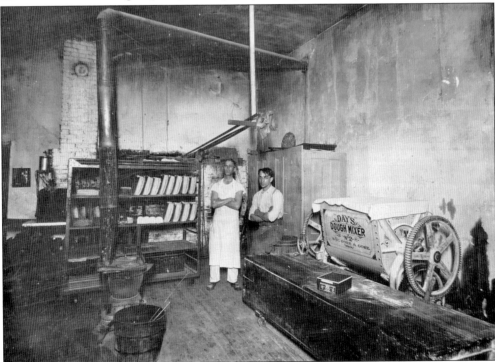

In 1909, Harry Wareham, who owned the city telephone company, purchased a lot on the corner of Fourth and Humboldt Streets for future expansion. In 1920, he sold the company to United Telephone (UTC), which, in 1925, built a new facility on the land Wareham had purchased. In 1939, Southwestern Bell acquired UTC, and the building became known as the Bell Telephone Building. It houses Riley County offices today. (Courtesy Riley County History Museum.)

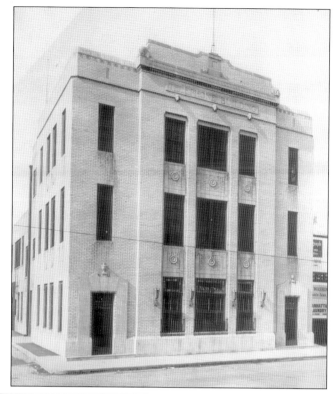

In 1915, Dr. Charles Frederick Swift and his daughter Dr. Belle Little opened the Charlotte Swift Hospital at Eleventh and Osage Streets (shown here in 1929). Dr. Little made rounds in an electric car and managed the 35-bed hospital after her father's death. In 1936, she sold the facility to the Sisters of St. Joseph, who renamed it Saint Mary Hospital. (Courtesy Riley County History Museum.)

Francis David Farrell was named dean of the division of agriculture and director of the Kansas Agricultural Experiment Station in September 1918. An innovative educator, Dean Farrell initiated the agricultural fair on campus in May 1921 to highlight the accomplishments of the division. This photograph captures the on-campus activities associated with the first fair. (Courtesy Special Collections, KSU.)

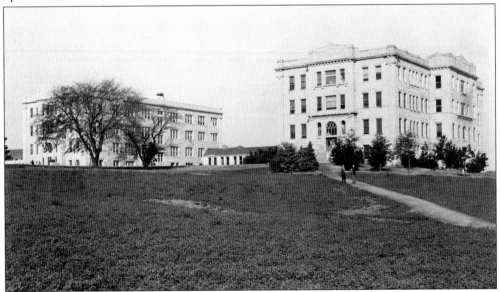

President Waters facilitated construction of an impressive new building composed of two wings connected to a large central structure. This building housed the six departments in the division of agriculture. The east wing of the building (right) was completed in 1913 and named Waters Hall in 1919. The west wing (left) was built in 1923; it is shown here in 1924. The Depression and World War II delayed completion until 1952. (Courtesy KSU Special Collections, Hale Library.)

On March 20, 1935, it was reported, "Manhattan today was experiencing western Kansas weather." Not officially in the middle of the Dust Bowl, Manhattan suffered on one day what citizens in western Kansas endured routinely. Around midday, when Prof. Julius Willard took this photograph on the campus of what had been renamed Kansas State College in 1931, police ordered the streetlights on, and children were dismissed from school. (Courtesy KSU Special Collections, Hale Library.)

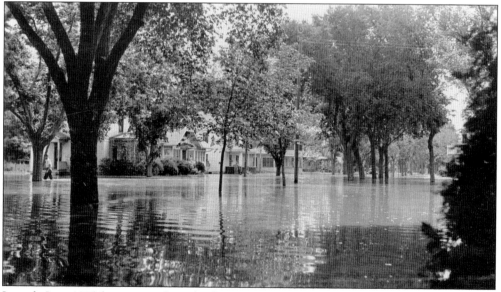

In early June 1935, heavy rains brought the Kaw River close to the water levels of 1903. By 2:00 a.m. on June 4, floodwaters already covered Fourth Street at Poyntz Avenue. By 6:00 a.m., water was coursing into residential areas west of downtown, as this photograph by Professor Willard shows. This shot was taken looking east, close to the intersection of Houston and Eleventh Streets. (Courtesy KSU Special Collections, Hale Library.)

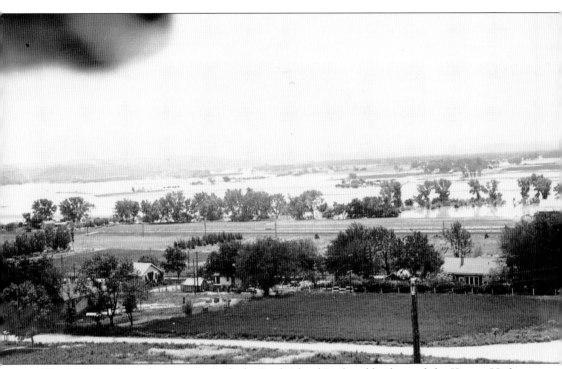

The 1935 flood was devastating. Both the Rock Island Railroad bridge and the Kansas Highway 29 bridge, the main routes into town, were washed out. The river current lifted farmhouses off their foundations and swept them downstream. The flood destroyed more than 250 outhouses and left 50 dead animals in yards and streets. Water and mud badly damaged 200 homes. Maj. Gen. Abram G. Lott, commander of Fort Riley, provided soldiers and boats to help with rescues. In total, the city suffered $700,000 in damages, an enormous sum in the middle of the Great Depression. At the end of June, a committee appointed by the chamber of commerce began to study "whether or not a dike system would be practical" protection for the city. (Courtesy Riley County History Museum.)

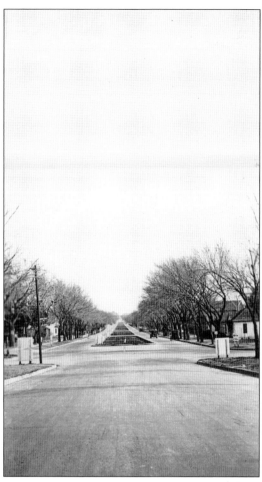

In 1930, pinched voters summarily rejected seven bond issues for city projects. Wages for city employees were slashed, as were salaries at the college. Commissioners spent $300,000 of privately raised relief funds between November 1931 and April 1932 but were unable to help 600 men qualified for assistance. Beginning in 1933, funding for civic projects—part of Pres. Franklin Roosevelt's New Deal—started to provide relief for the unemployed. These two photographs by Professor Willard show a sewer line project down Poyntz Avenue, one of the first Works Progress Administration (WPA) projects in the city. The right photograph shows Poyntz Avenue, looking east from Seventeenth Street, before the project began. The below photograph shows the boulevard removed and work crews digging the sewer line trench. This project prompted intense public debate before the commission undertook it. (Both, courtesy KSU Special Collections, Hale Library.)

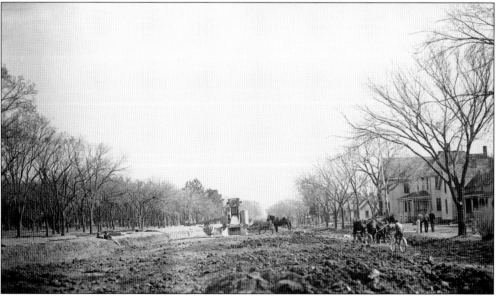

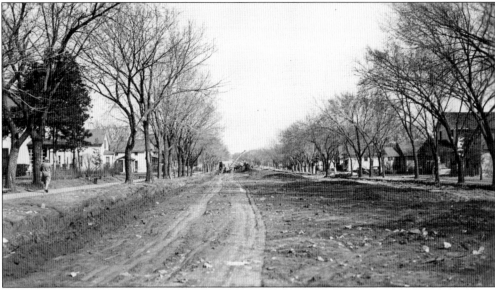

During the Depression, Manhattan and KSAC received relief funding from the WPA, the Public Works Administration (PWA), the Civilian Conservation Corps, the National Youth Administration, and the Public Works of Art Project. Having the former mayor of Manhattan, Evan Griffith, as the state director of the WPA certainly improved the odds of funding reaching the city. These two photographs by Professor Willard show the Poyntz Avenue sewer project nearing completion (above) and the hourly wage scale for a WPA project in the city. Relief funding was intended for residents only, and the city actively discouraged transients from remaining in town. However, Katherine Godfredson, the executive secretary of the Red Cross, did provide aid "for the needy who [had] made their homes [in Manhattan] in the past." (Both, courtesy KSU Special Collections, Hale Library.)

PROJECT No. 5170
— WAGE SCALE —

FORM BUILDER	1.10
CARPENTER	1.10
BRICKLAYER	1.10
MASONS	1.10
CRANE or DRAGLINE OPERATOR	1.10
CONCRETE FINISHER	.75
HOIST OPERATOR	.75
FORMSETTER	.62½
CONCRETE WORKER	.62½
MIXER OPERATOR	.62½
JACKHAMMER OPERATOR	.62½
MORTAR MIXER	.62½
TILE LAYER	.62½
TRUCK DRIVER Over 1½ Ton	.50
TRUCK DRIVER 1½ Ton and Under	.45
COMMON LABOR	.45
TRUCK and DRIVER over 1½ Ton	1.00
TEAMSTER and TEAM 3 up	.75
TEAMSTER and TEAM 2 up	.65

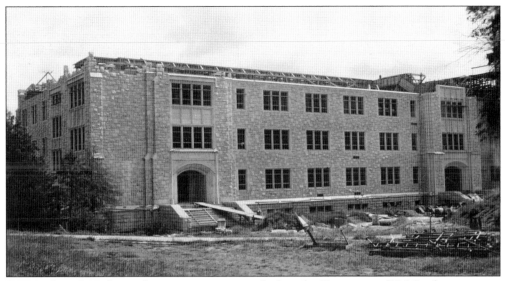

During the relatively good economic times just before the Depression, KSAC administrators made plans to build a new physical science hall. Prospects for securing state funding during the worst years of the Great Depression were nil. Walter A. Huxman, Democratic governor of Kansas, traveled to Washington, DC, and made the case for a new science hall directly to President Roosevelt. The governor's success resulted in $272,533 in PWA funds that, when added to a state appropriation, matched construction costs of $435,000. Below, the governor and other dignitaries attend a cornerstone ceremony on April 20, 1938. The above photograph shows Willard Hall under construction. The regents named the hall in honor of Prof. Julius Willard for his 54 years at the college. The school held a grand dedication ceremony for the completed building in August 1939. (Both, courtesy KSU Special Collections, Hale Library.)

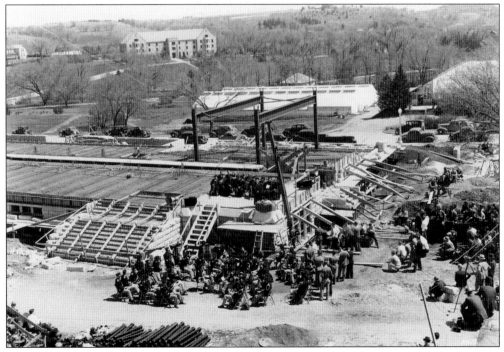

Evan Griffith (1897–1961) was a successful businessman and well-loved public servant. He possessed a passion for youth baseball, as portrayed in this 1928 photograph (left) of him in uniform. Children met for practice on small city lots, and Griffith provided equipment for those youngsters who needed it. As a businessman, he was president of the Union National Bank, president of the K-State Endowment, and a co-owner of Griffith Lumber Company. A Democrat, he was elected mayor in 1931, appointed state reemployment director in 1934, and named by President Roosevelt to serve as the Kansas director of the WPA. His work to provide funding for relief projects was honored by the city commission, which named the WPA-funded baseball stadium Griffith Field. The completed project is shown in the above photograph. (Both, courtesy Riley County History Museum.)

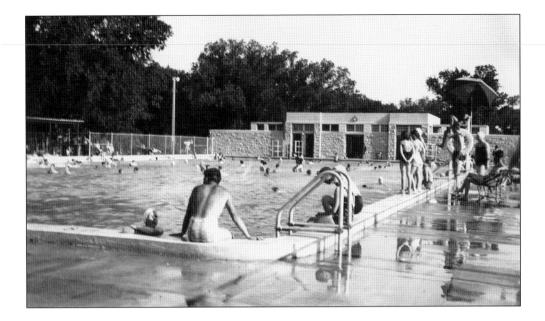

Two of the last major New Deal projects in the city were City Park Pool and the county jail. The city commission decided to build two pools, one in City Park for white residents, and the other on the playground adjacent to Douglas School for African Americans. The city acquired PWA funds that were matched by a voter-approved bond issue in August 1938. The above photograph shows opening day of City Park Pool on May 20, 1939. Restricted to the much smaller Douglas Park Pool completed in August 1939, African Americans were allowed to swim in City Park Pool one day a year, during Emancipation Day Celebrations in August. After the event, park staff would drain the pool and refill it for white children. The new county jail (below) was also a PWA project completed in 1939. (Both, courtesy KSU Special Collections, Hale Library.)

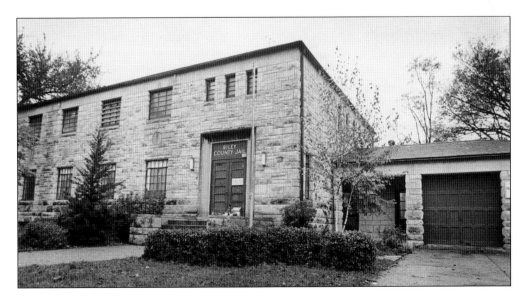

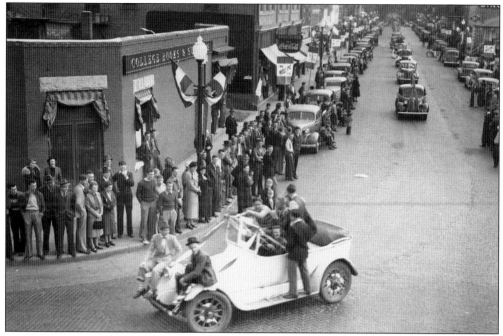

By 1939, unemployment had receded and student enrollment at the university had recovered from a low of 2,367 in 1935 to 4,082 in 1939. This 1938 photograph of a homecoming parade on Moro Street shows one of the many celebrations in the student area of town. The Cooperative Bookstore is seen on the corner of Moro and Manhattan Avenue. (Courtesy Riley County History Museum.)

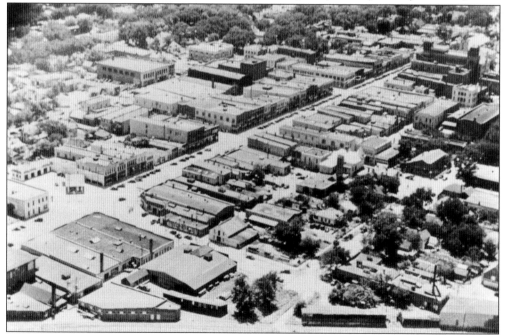

This aerial photograph of downtown in 1938 shows the city recovered from the 1935 flood and the economic troubles of the Great Depression. Relief, however, was short lived, as the community prepared for World War II. (Courtesy Riley County History Museum.)

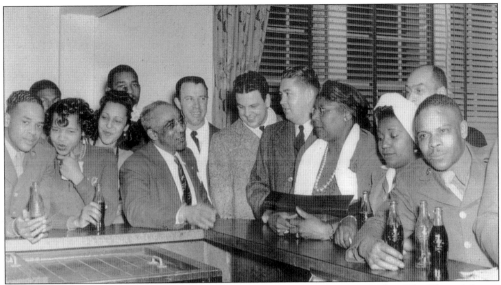

World War II meant rapid adjustments to the influx of soldiers at Fort Riley. The United States Service Organization acquired the Community Building for white soldiers and built another recreation facility across the street from Douglas School for African American soldiers, the Douglass Center. This photograph is of a social gathering of black soldiers at the new center. (Courtesy Riley County History Museum.)

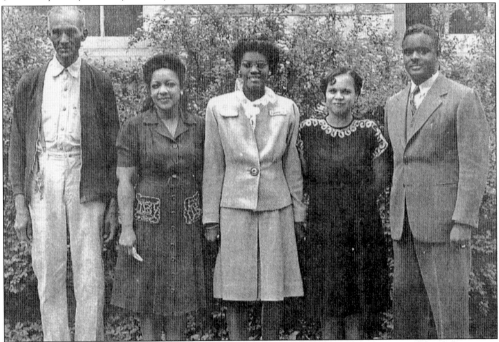

Staff members of Douglas School pose for a photograph in 1946. Shown here are, from left to right, custodian Harvey Maxwell, teachers Mrs. Davis, Hattie Woods, and Mrs. Warren, and principal Fred Wilhoite. After the war, the school and its swimming pool became the center of a burgeoning civil rights movement led by the Manhattan Civil Rights Committee. Abby Marlatt, granddaughter of Washington and Julia Marlatt, was an effective ally. (Courtesy Claflin Books and Copies.)

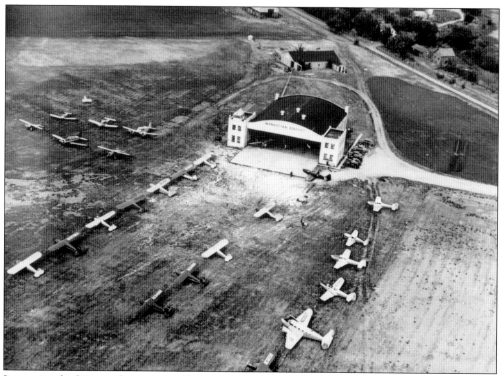

Improving facilities at the airport took on greater importance during the war. City voters approved a bond issue to acquire the airport land in November 1940. In March 1946, the city made arrangements for the Army to use the airport, and in March 1948, the city and federal government jointly funded building the first concrete runway. This aerial photograph shows the airport in 1947. (Courtesy Riley County History Museum.)

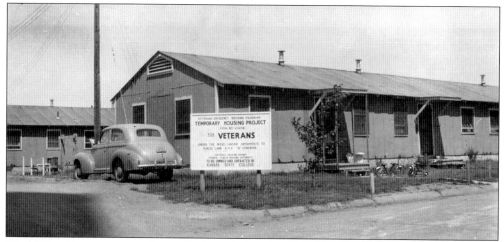

World War II veterans eagerly enrolled in KSC under the provisions of the GI Bill. Enrollment mushroomed, from 2,206 in 1945 to 6,522 in 1946. The rapid increase resulted in a severe housing shortage for married students, many with young children. The college responded by moving over 230 units of Army housing from Fort Riley as "temporary" accommodation for these returning veterans and their families. This 1947 photograph shows one such unit. (Courtesy KSU Special Collections, Hale Library.)

Six

GROWING PAINS
1950–1980

Halfway through the 20th century, Manhattan citizens began transforming their city and university. Contractors hustled to build enough housing to shelter a rapidly increasing population. Voters embraced the manager/commission form of city government that promised increased efficiency. The first five office-seekers elected included Lillian Bascom, the first woman elected to city government. Kansas State College became Kansas State University, a new profile indicating its enhanced standing as a research institution. Under the guidance of a world-wise president and gifted research professors, the university played a major role in the global "green revolution."

It was not long before these newly reformed institutions were put to a severe test. In June 1951, one of the largest floods ever to sweep down the Kaw River inundated the city, making the whole downtown a watery wasteland. On Poyntz Avenue, floodwaters crested at over five feet and caused millions of dollars in damage. Once the water receded in July, it took months, and in some cases years, before full recovery was a reality.

The disaster ignited powerful, heated rhetoric. The primary battle was over the proposed Tuttle Creek Dam and Reservoir, which would condemn thousands of acres of farmland in the Blue River Valley. How to deal with severely damaged downtown buildings and where new commercial retail business should be located generated intense debate over issues of historic preservation, suburban sprawl, and long-range city planning.

The 1950s and 1960s were also the era of civil rights challenges, locally and nationally. City commissioners responded with the creation of a human rights advisory board. The school board proactively desegregated the city's elementary schools well before the implementation of *Brown* v. *Topeka Board of Education*. University presidents addressed discrimination on and off campus. KSU women and students of color made significant gains in several intercollegiate sporting programs. The Vietnam War and antiwar demonstrations tore at the social fabric of the community. Throughout, Manhattanites found strength in their tradition of social reform and embrace of economic development to prosper in an emerging world of international economic and social complexity.

In July 1951, voters approved a new city hall and auditorium (which was to honor World War II servicemen and women) across from City Park. In September 1951, the city purchased the land, and in January 1954, it solicited bids for the building. The new city hall was dedicated on September 26, 1955, and still serves as the seat of city government. (Courtesy City of Manhattan.)

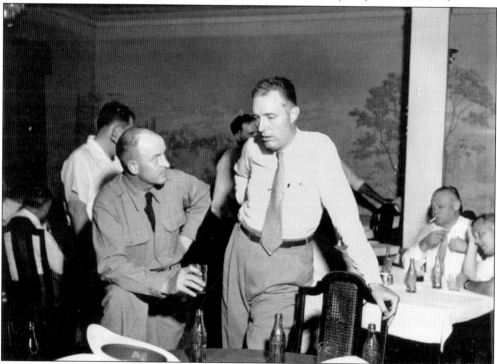

In April 1950, Manhattan voters decided to adopt the current city manager/commission form of government. The first five-member commission was elected on April 6, 1951. William Barton Avery (right) became the first city manager on June 5, 1951. (Courtesy City of Manhattan.)

Post–World War II Manhattan quickly grew, from 11,660 residents to more than 19,000 in 1950. Rapid growth paved the way for suburban residential development. This 1950s photograph shows the Northview development, a district of ranch-style housing popular throughout the United States. (Courtesy Riley County History Museum.)

Department-store chains modernized during the 1950s to meet and shape consumer demands. This photograph shows the Sears department store as it appeared in 1952. A three-day opening celebration flouted the store's glass front displays, employee profit-sharing plan, and the single-level floor plan for merchandise. The manager boasted that "display men" were hired who specialized in "eye appeal." (Courtesy Riley County History Museum.)

By 6:00 p.m. on June 29, 1951, floodwaters from the Big Blue and Kansas Rivers had crested in Manhattan. But the worst was yet to come. Rain began to fall again on July 9, and a second torrent of floodwaters rapidly inundated the city. This time, the Kansas River crested a full six feet higher than it had the week before. By July 13, more than 70 city blocks lay completely immersed, resulting in the evacuation of more than 20,000 people. One person drowned, and residents suffered more than $22 million in property damage. When Red Cross shelters proved inadequate, university president McCain opened the campus gyms and hospital. Armed soldiers guarded downtown buildings from looters. The 1951 flood profoundly altered the course of city development. Here, a woman walks through the muddy aftermath of the flood. (Courtesy City of Manhattan.)

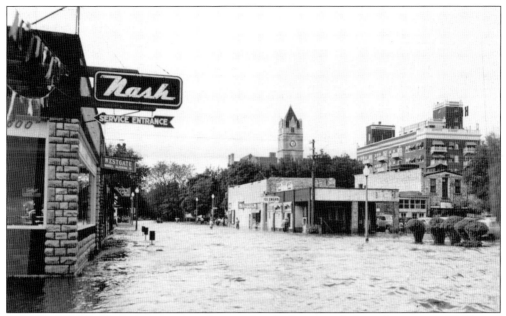

On July 11, 1951, when this photograph was taken looking north from the corner of Fifth and Houston Streets, floodwaters were still rising. Note the tops of parking meters barely visible above rushing waters. Two blocks away, the Gregg family came down from their perch on the second floor of their home on Laramie Street, boarded the evacuation boat, and joined others in shelters on higher, dry ground. (Courtesy City of Manhattan.)

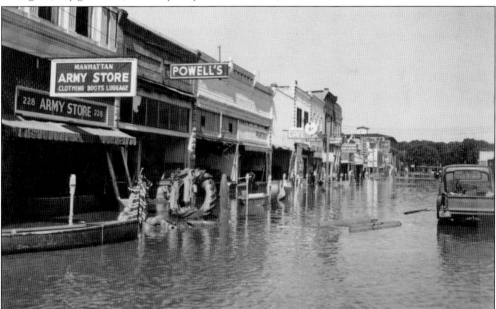

This view looks east on Poyntz Avenue from the 300 block on July 18, 1951. The water is low enough for a pickup truck to drive down the street. A rescue boat is tied up to a parking meter. Water pressure shattered the front windows of every business along the avenue. The only structure in this photograph extant today is the one with the Army Store sign out front. (Courtesy City of Manhattan.)

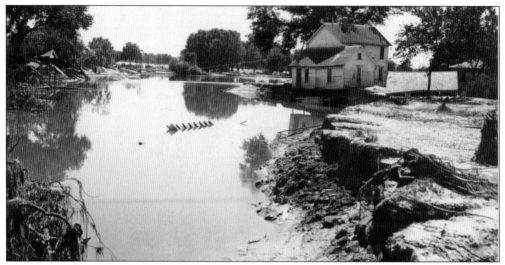

The neighborhood south of the Union Pacific and Rock Island Railroad track was called the "bottoms" for a good reason; the unpaved streets were directly adjacent to the north bank of the Kaw River. This photograph shows Pottawatomie Street looking west from Third Street. The flood destroyed nearly every house in this portion of the city, leaving hundreds homeless. (Courtesy City of Manhattan.)

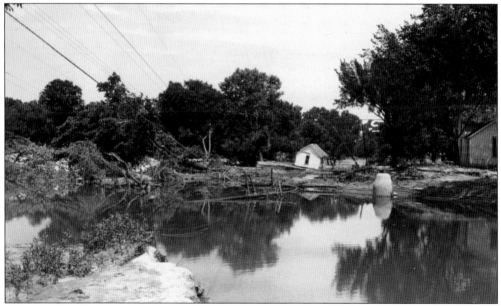

This photograph, taken on July 24, 1951, is looking east along Pottawatomie Street toward the river from Third Street, nearly two weeks after the worst of the flooding. The destruction in this part of town is evident. Houses are off their foundations, power lines are down, and the street is completely scoured and littered with debris. Citywide, more than 50 houses were swept downstream. In the bottoms, many residents still relied on outhouses, and pollution problems posed serious health risks. The water system in the city suffered severe damage, and the city engineer warned residents to boil all of their drinking water as a typhoid preventative. Displaced residents from this part of town, primarily African Americans, were still living in World War II–era trailers parked in the "Douglass School area" nearly a year later. (Courtesy City of Manhattan.)

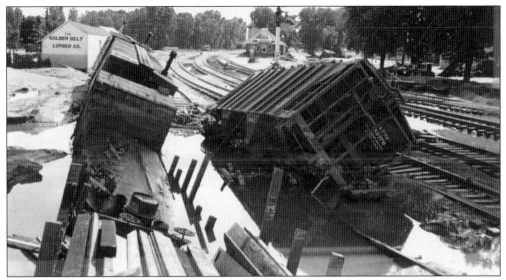

For several days in July, the only way to get in and out of Manhattan was by boat. The flood weakened railroad bridges, washed away rail tracks, and sent railroad cars downstream. Army planes dropped inflatable rafts and food rations to those stranded on high ground. Army helicopters flew rescue missions from downtown to the campus. At the high point of flooding, the currents were powerful enough to prevent rescue boats from reaching some areas downtown. The power of those currents is graphically illustrated in this photograph showing overturned boxcars just to the east of the Union Pacific depot. (Courtesy City of Manhattan.)

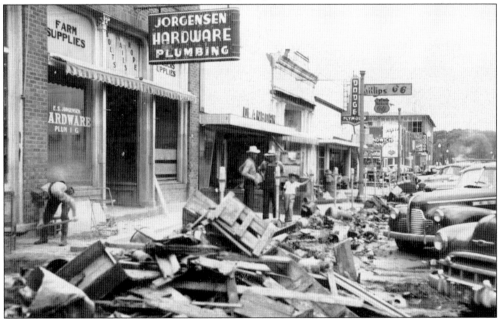

The downtown business district suffered the greatest damage, estimated to have topped $22 million. Businesses frantically moved merchandise to higher floors as floodwaters poured into their buildings. By July 13, the water was six feet deep in the lobby of the Wareham Hotel, and the few remaining guests were stranded on the second floor. This photograph shows the cleanup effort under way on the east side of the 200 block of Poyntz Avenue. (Courtesy City of Manhattan.)

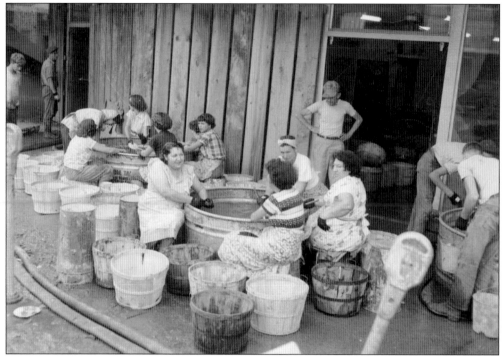

The smell of rancid mud filled the air for weeks after the flood. Downtown merchants hired people at twice their regular wages to clean their merchandise and stores. This photograph of Duckwalls variety store on Poyntz Avenue shows women working to clean flood-damaged merchandise. The owners of Don and Jerry's Clothing Store sent suits to Topeka for dry cleaning, and then sold them for 10¢ on the dollar. Eva Lee Butin, a married student at the time, recalled how the hot July days following the flood baked the mud into a hardened mass that was exceptionally difficult to remove. Without hot water for proper cleaning, embarrassed flood victims smelled like river mud for quite some time. Some clothing stores simply took their flood-drenched merchandise and laid it out for KSC students to take whatever they wanted. The only requirement was that clothes had to be washed immediately or they soon "rotted out." (Courtesy City of Manhattan.)

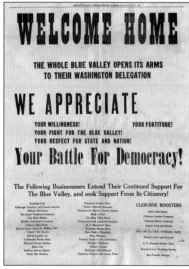

Prior to the 1951 flood, the city commission, in keeping with general sentiment, passed a resolution siding with the residents in the Blue River Valley in their opposition to "Big Dam Foolishness." This broadside was published in the Blue Valley News on June 22, 1956. (Courtesy KSU Special Collections, Hale Library.)

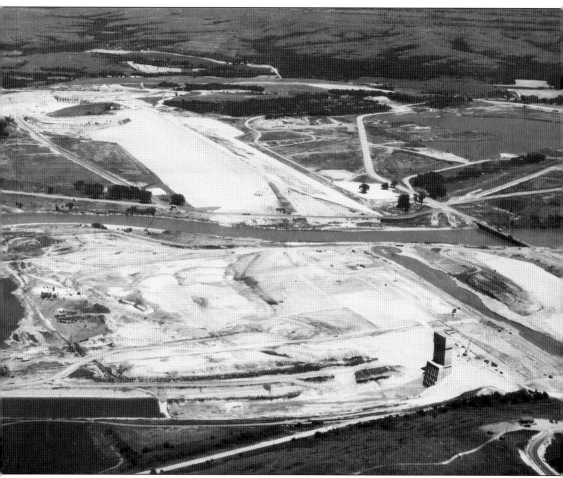

The 1951 flood changed many city residents' position on flood control. The city commission took steps to work with the Army Corps of Engineers for a levee system bordering the north side of the Kansas River and supported the building of Tuttle Creek Dam and Reservoir, photographed here under construction. The completed dam was dedicated in 1963. (Courtesy Riley County History Museum.)

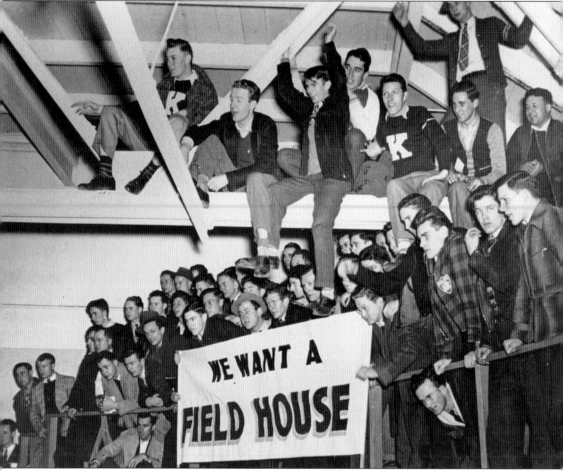

After 1945, big-time college sports took hold at KSC. Students, however, were tired of cramming into Nichols Gymnasium to watch their Wildcat teams play. Tickets given to students were good for only one half of the games played in Nichols, because it could not accommodate all of the students at the same time. Students were vocal in their demands for a new facility, as this photograph demonstrates. (Courtesy KSU Special Collections, Hale Library.)

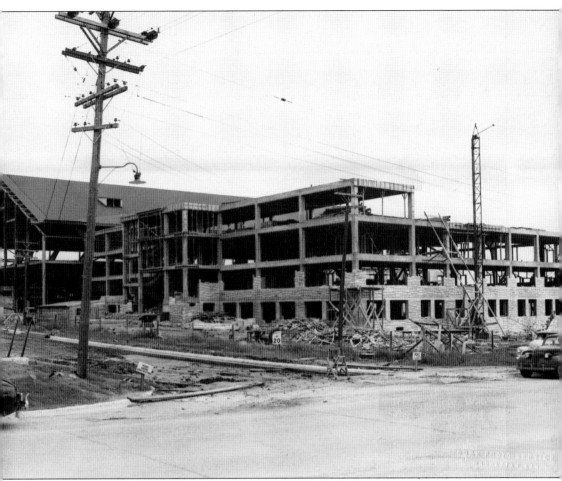

Overcrowding in Nichols Gymnasium meant that nonstudents and faculty were barred from attending most sporting events. By 1949, plans had moved ahead for a new field house, and construction began in 1951. The facility was named for Mike Ahearn, the revered former director of athletics, who died in February 1948. (Courtesy KSU Special Collections, Hale Library.)

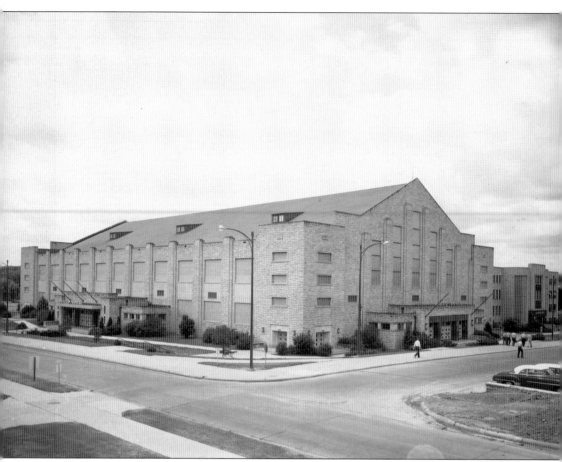

Students wrote in the *1950 Royal Purple* that "the promised program seemed almost too good to be believed—fieldhouse, better inducements to better athletics, big public relations programs, and, most important, a winning team." To say that fans and students in 1950 were looking forward to a fully finished field house is an understatement. They all watched the construction anxiously as Charles Marshall, the state architect, supervised the construction of the facility. In 1951, crews put the finishing touches to the building, a $1.77 million undertaking that included a separate gymnasium for classes and intramural sporting events. This photograph shows Ahearn just after it was completed. (Courtesy KSU Special Collections, Hale Library.)

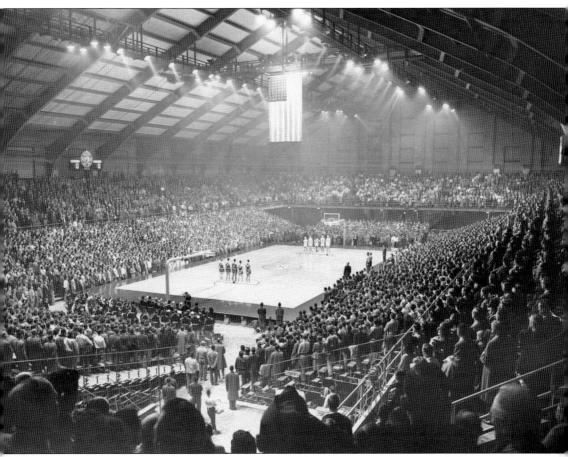

The new field house was the fifth largest in the United States. In 1952, before a crowd of 13,000 fans, the Wildcats defeated the Jayhawks 81-64. In fact, the field house proved an excellent venue for fans and players alike, as coach Jack Gardner's team was undefeated in Ahearn that season. (Courtesy KSU Special Collections, Hale Library.)

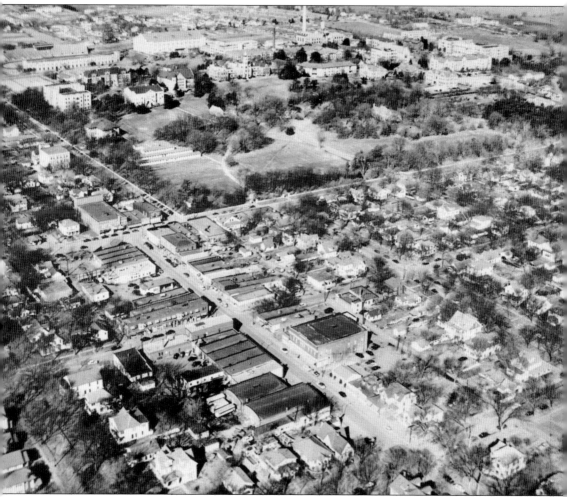

As this 1953 aerial photograph of Aggieville and the KSC campus shows, residential neighborhoods and retail businesses had filled the gap between the downtown and campus. The first tentacles of post–World War II developments appear in the upper portions of the photograph. (Courtesy Riley County History Museum.)

KSC president James McCain (left), Milton Eisenhower (center), and Kansas governor Fred Hall attend the dedication of the new arts and science building, named in honor of Milton Eisenhower. As president of KSC, Eisenhower guided the college through a period of rapid growth after World War II. (Courtesy KSU Special Collections, Hale Library.)

Harold Robinson was the first African American to play for a KSC intercollegiate sports team. KSC was first in the Big Seven Conference to award an athletic scholarship to a player of color. In 1949, Robinson began his career on the football team under the supportive guidance of Coach Ralph Graham and KSC president Eisenhower. (Courtesy KSU Special Collections, Hale Library.)

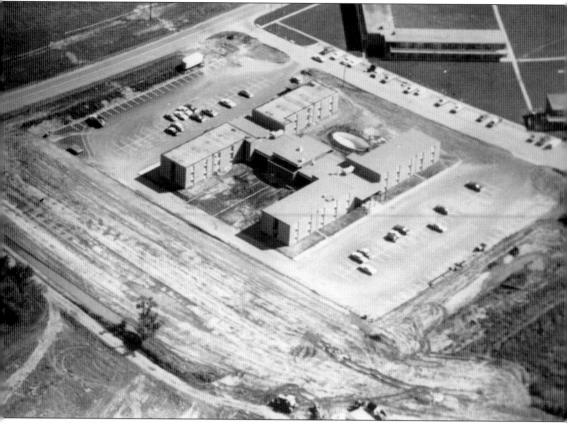

In the 1950s and 1960s, housing was racially segregated, both on and off campus. The athletic coaches at KSC, however, wanted players on integrated teams to live with each other as well as play with each other. Edwards Hall was built in 1968 to provide an integrated dormitory for KSU athletes. (Courtesy KSU Special Collections, Hale Library.)

One of the most effective civil rights leaders in Manhattan was James Edward Butler (1916–2012), shown at right in his Army uniform. Standing with him is William Baker. Butler served on the city Human Relations Board and later chaired the Kansas Commission on Civil Rights. (Courtesy Claflin Books and Copies.)

Veryl Switzer was an all-star football player for Kansas State University in 1951, 1952, and 1953. After graduation, he played professional football for the Green Bay Packers, served in the Air Force, and taught in Chicago. In 1969, he was hired by KSU president McCain to improve the "racial composition" of the university. (Courtesy KSU Special Collections, Hale Library.)

Lillian Bascom (1897–1987) broke new ground for women when voters elected her to the city commission in April 1951. Bascom was well known for her civic engagement. She chaired the library board, the county welfare board, and was president of the League of Women Voters and the American Association of University Women. According to several accounts, she played a major role in restoring the city after the flood of 1951. (Courtesy Charles and Kay Bascom.)

Murt Hanks (1933–1989) often cited Thomas Paine, who lived by "protecting the rights of others." Hanks was only the second person of color elected to city government (1969–1977) and represented the city twice as mayor. Active in the civil rights movement, he was the first equal opportunity officer at Fort Riley, played a key role in the city's fair housing ordinance, and helped to implement public transportation for the elderly. (Courtesy Riley County History Museum.)

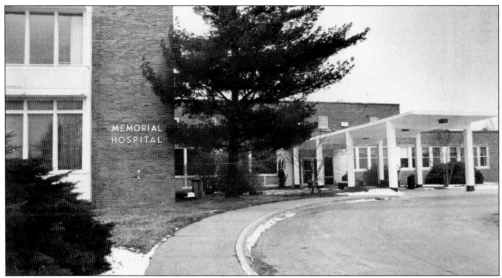

Riley County Memorial Hospital opened in May 1954. In 1962, the institution was renamed Memorial Hospital, and in 1996, its directors agreed to a merger with St. Mary's Hospital, becoming Mercy Regional Health Center. It is currently operated by Via Christi. (Courtesy Riley County History Museum and *Manhattan Mercury*.)

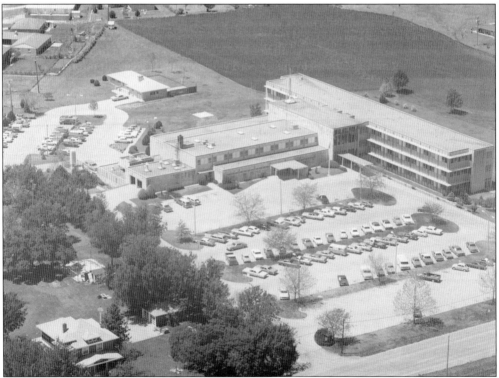

By 1942, the Sisters of St. Joseph realized that Parkview Hospital was not fully meeting the needs of the community. Assisted by Evan Griffith, they purchased 22 acres in 1957, where Mercy Regional is today, and constructed a $2.5-million, 104-bed facility. This photograph shows St. Mary's Hospital after it opened in June 1961. (Courtesy Mercy Regional Health Center.)

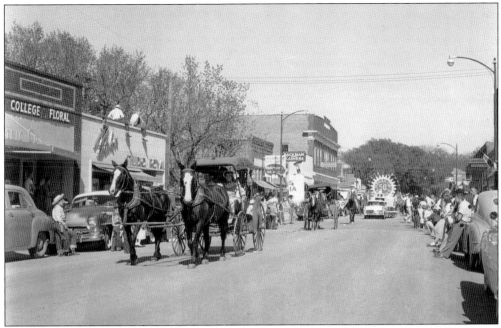

Manhattan celebrated its centennial in June 1955. Parades, concerts, and historical displays were the order of the day. People eagerly participated in several historical reenactments, including wagon-train drives and 19th-century costumes. This photograph shows the parade as it made its way through Aggieville. (Courtesy Riley County History Museum.)

Retired professor George A Filinger created the legendary character Johnny Kaw. Written for the city's centennial celebration, Filinger's fanciful story became popular with residents, and in the spring of 1965, Prof. E.J. Frick petitioned the city commission for the right to erect a 25-foot-high "monument" in City Park to commemorate Johnny Kaw's exploits. The unique statue still entertains young and old alike. (Courtesy Riley County History Museum.)

The Manhattan site of The American Institute of Baking (AIB) was dedicated in April 1978. The AIB was founded to meet the need for industrial research and food technology transfers during World War I. The institute had been headquartered in Chicago, but in the 1970s, an independent study recommended moving AIB headquarters to Manhattan, which the directors did in 1978. (Courtesy Riley County History Museum and *Manhattan Mercury*.)

Large retail stores looked for new locations in anticipation of the westward growth of the city. The Dillons grocery company was the first to build west of the new city suburbs. It became the anchor of the first suburban shopping center, named Westloop. This 1961 photograph shows the Dillons store in the undeveloped part of Manhattan. (Courtesy Riley County History Museum.)

Public concern about the spread of commercial development east and west of downtown led to debates over downtown viability and the hidden costs of urban sprawl. After a lengthy debate, the city approved the building of a K-Mart to the east of downtown. This photograph shows the early construction of the store in 1973. (Courtesy Riley County History Museum and *Manhattan Mercury*.)

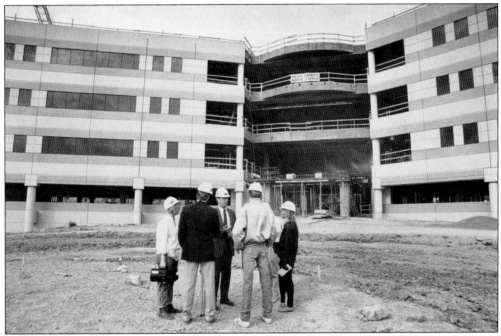

The Kansas Farm Bureau has played an important role in Agricultural Extension since its founding in 1920. By state law, county-organized farm bureaus could petition the college extension service for funding for county agents. The bureau had its first office in downtown, outgrew that one, relocated west of the campus, and built its current office complex even farther west, as shown here in November 1988. (Courtesy Riley County History Museum.)

In 1965, the city commission, the school board, and the Riley County Commission approved a joint agreement that led to the creation of a recreational park in the northwest part of the city. The high school football stadium, the county fairgrounds, and a municipal pool were all built on this land. The park was given the name CICO (City/County) Park. (Courtesy Riley County History Museum and *Manhattan Mercury*.)

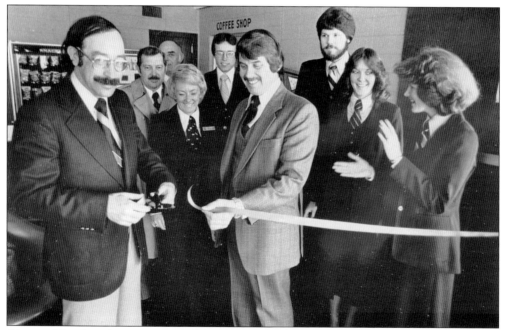

Air travel has long been an essential component in the economic growth of the city. In 1951, Continental Airlines committed to using the airport if the city would lengthen the runway, which it did in 1952. Mayor Robert Linder (left) cuts a ribbon inaugurating the beginning of Royal Airline service in 1979. (Courtesy Riley County History Museum and *Manhattan Mercury*.)

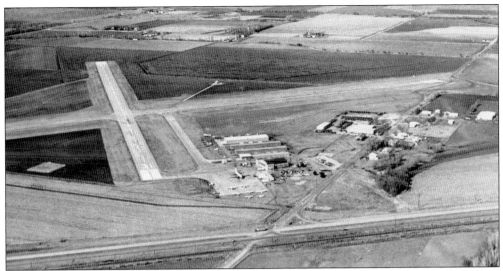

By 1977, when this aerial photograph was taken of the Manhattan Municipal Airport, the city had already built an administrative building in 1958, created an airport advisory board in 1967, and contracted studies to assess the capital requirements for making the airport accessible to jets, including additional improvements to its runway. (Courtesy Riley County History Museum and *Manhattan Mercury*.)

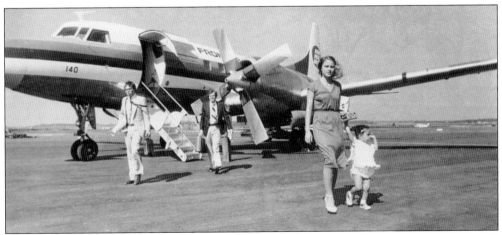

By 1980, the city had hosted a number of different airline companies. The service with Continental Airlines was discontinued in 1961, and Central Airline began serving Manhattan. In 1977, Frontier Airlines became the passenger provider. In this photograph, passengers disembark from a Frontier flight. (Courtesy Riley County History Museum and *Manhattan Mercury*.)

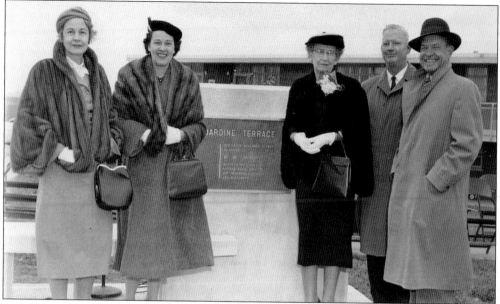

Married students attending KSC, and especially the veterans attending on the GI Bill, chaffed at living in the temporary housing of World War II barracks. KSC president McCain (far right) oversaw the completion of "the long promised and much needed married students housing" project, Jardine Apartments, in 1957. Effie Jardine is to the right of the plaque, and her daughters Marian Stannus and Ruth Hardie are to the left. (Courtesy KSU Special Collections, Hale Library.)

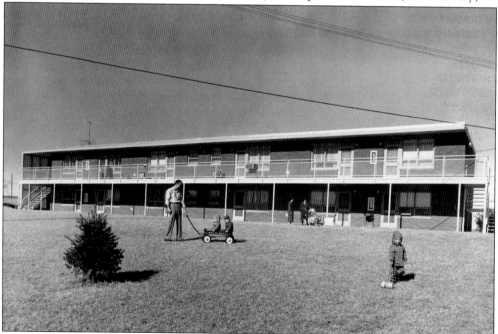

The Jardine complex provided nearly 200 families with furnished one- and two-bedrooms units. A common play area provided safe recreation for children, and centralized laundry facilities eliminated trips to downtown Laundromats. The residents organized their own governing association and elected a mayor to represent them. (Courtesy KSU Special Collections, Hale Library.)

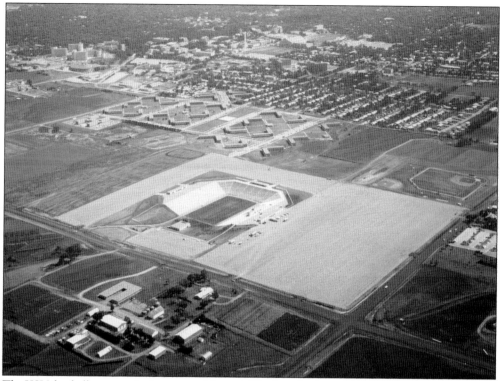

The KSU football program had outgrown Memorial Stadium by the mid-1960s, and the administration made plans for a new stadium northwest of the main campus to provide greater seating and more parking. In 1968, the new 35,000-seat KSU Stadium was completed and hosted its first game in September of that year. (Courtesy KSU Special Collections, Hale Library.)

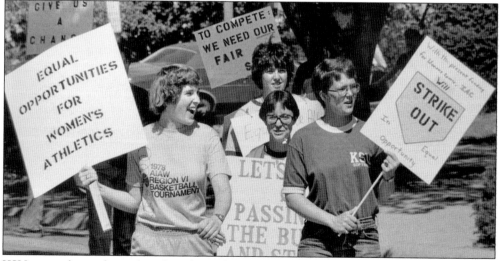

KSU women began demanding the right to play intercollegiate sports in the 1960s. In the 1968–1969 academic year, the administration gave women the right to play intercollegiate basketball. The first women's coach, Judy Akers, was a great advocate for the equal treatment of women athletes under Title IX of the Civil Rights Act. In 1978, she lost her job despite a winning record of 206-94. (Courtesy Riley County History Museum and *Manhattan Mercury*.)

Dr. David McKnight, owner of the former Dewey Ranch, in 1975 indicated a desire to sell the 8,000-acre ranch. The Nature Conservancy expressed interest in it as a tallgrass prairie preserve. Working quietly behind the scenes, Profs. Lloyd Hulbert and Ted Barkley convinced Katherine Ordway, the heiress of the 3M Company, to provide the $3.6 million asking price. She donated it to the conservancy, which in turn purchased the land and then signed a long-term lease

arrangement with the division of biology and the university to manage the site. Hulbert directed an ambitious scientific research program. The National Science Foundation established the Long Term Ecological Research (LTER) program in 1980. Guided by Hulbert, the Konza Prairie Research Natural Area, later renamed the Konza Biological Research Station, became one of the first six LTER sites in the nation. (Courtesy KSU Special Collections, Hale Library.)

Prof. Lloyd Hulbert realized a dream with the creation of Konza Biological Research Station. He received his doctorate from Washington State University in 1953 and landed a position in the Kansas State Department of Biology in 1955. His lifelong work centered on the ecological effects of wildfires. He discovered that the tallgrass prairies of the Flint Hills suited his academic pursuits. (Courtesy KSU Special Collections, Hale Library.)

Prof. Ted Barkley also collaborated in the creation of the Konza Biological Research Station. As a graduate student at Columbia University, his lab partner was Katherine Ordway. It was Barkley who established contact with Ordway, who provided the Nature Conservancy with $3.6 million to purchase the old Dewey Ranch. (Courtesy KSU Special Collections, Hale Library.)

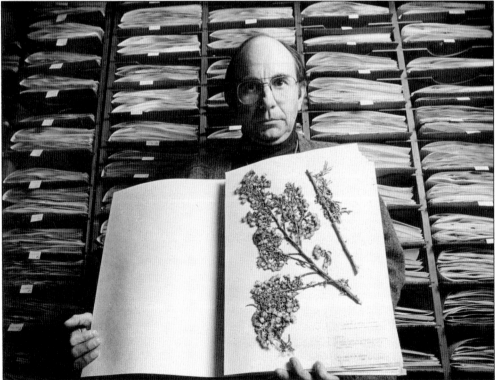

In 1956, the International Cooperative Administration contracted with KSU to provide agricultural, veterinary, and home economic assistance and training to colleges in the central region of India. By the time the program ended in 1972, 10 Indian colleges had participated, with the help of 59 faculty members from the university. In this photograph, an Indian student arrives to study at KSU. (Courtesy KSU Special Collections, Hale Library.)

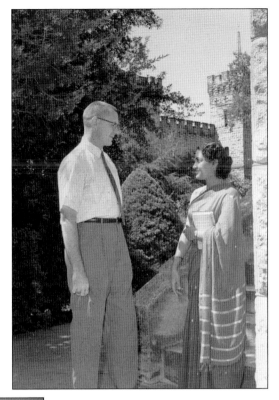

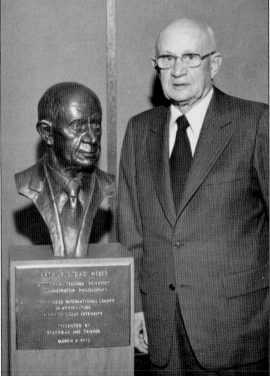

Dean H.D. Weber, known by students as "Dad" Weber, played the lead role in establishing international agricultural programs with India and Nigeria. By 1958, eight KSU faculty were living and teaching in India, and six exchange scholars from India were studying on the Manhattan campus. Weber retired in 1968 to international acclaim for his efforts and leadership. (Courtesy KSU Special Collection, Hale Library.)

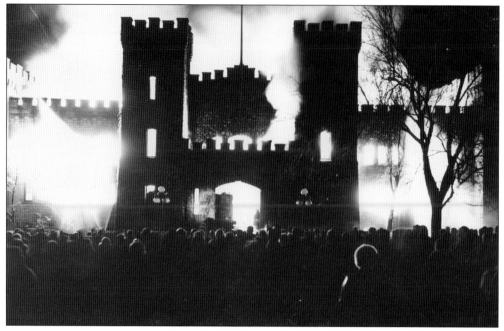

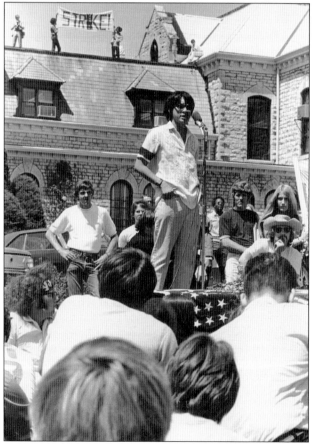

On December 12, 1968, a student forum to address faculty-student relationships turned raucous. Andy Rollins, a student protest leader, suggested burning down Anderson Hall. The next night, an arsonist set Nichols Hall ablaze. As shown in this photograph, flames engulfed and destroyed all but the stone shell of the building. Rollins was out of town that night, and the culprit is still unknown. (Courtesy KSU Special Collections, Hale Library.)

Student protests on campus began in the mid-1960s over mandatory enrollment in Reserve Officer Training Corps classes. In 1968, a chapter of the Students for a Democratic Society, known for its antiwar stance, was formed on campus. This May 6, 1970, photograph captures the student demonstration protesting the Kent State shootings. (Courtesy KSU Special Collections, Hale Library.)

Seven

Manhattan Becomes a Regional Center
1980–Present

Successful, managed growth over a 30-year period has made Manhattan unique among Midwestern cities in spite of the challenges posed by national and international trends. Throughout, Manhattan has continued to build upon its traditional economic strengths—Kansas State university and the US Army at Fort Riley.

None of this came easily or smoothly, as the placement of a mall, and its relationship to downtown redevelopment, assumed center stage in the 1980s. An extended public conversation led to the demolition of several city blocks to make room for a large indoor mall downtown rather than on the outskirts of the city. This decision sparked new conversations about historic preservation and quality of life. Voters responded by supporting economic development programs that continued to build upon downtown redevelopment, job creation, and public attractions, all of which have made Manhattan a regional retail center and tourist destination. More recently, the city has moved toward developing a knowledge-based economy based upon biotech industries.

Beginning in 1986, under Pres. Jon Wefald, Kansas State University was rated among the best public universities in the nation. Under his direction, the university was recognized for its scholarly achievements, improved educational environment, and, under Coach Synder, its transformation into a football powerhouse. By the time Wefald retired, another 4,000 students attended the university. Current president Kirk Schulz guides a university offering 250 undergraduate majors, 65 masters degrees, and 45 doctoral degrees to more than 23,800 students from every state in the union and 90 foreign countries.

Also in this same period, Fort Riley's fortunes directly affected the direction of the city. The 1st Division, or the Big Red One, served in numerous important combat and peacekeeping missions: Desert Storm (1990–1991), the Balkans (1996–2003), Iraq (2002–2012), and Afghanistan (2003 to the present). When the Army moved the 1st Division to Germany in 1996, the future of Fort Riley seemed to be in doubt. However, in 2006, as a result of regional cooperation and Defense Department policy changes, the 1st Division returned to Fort Riley, where it continues a reciprocal relationship with the city.

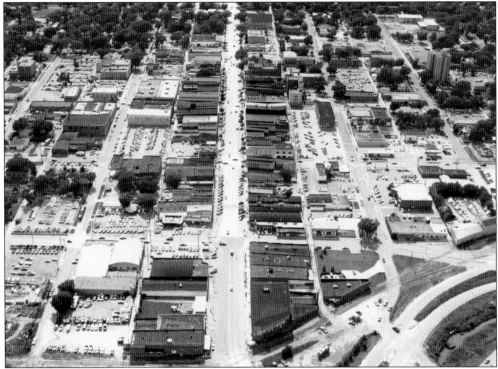

Widespread concerns over keeping downtown the commercial and cultural center of the community led to the city commission rejecting several attempts to place a mall on the outskirts of the city. In March 1976, the Downtown Redevelopment Advisory Committee was formed to lead and channel public opinion as to how best to approach the building of a retail mall. By 1979, Mayor Terry Glasscock summed up public opinion by noting that downtown would satisfy the need for a regional shopping center and "solve the possible deterioration of the older part of town." The results of building the downtown mall are revealed in these two photographs, one taken of the Poyntz Avenue corridor before mall construction (above), and the other after the completion of the mall in 1987. (Both, courtesy KSU Special Collections, Hale Library.)

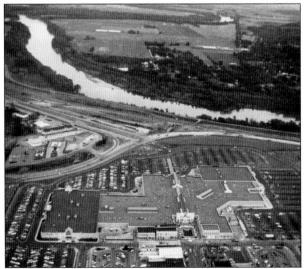

Scores of meetings by the advisory committee, the planning board, and the city commission finally led to the creation and approval of the Central Business District Redevelopment Plan in December 1983. Forest City Retail Properties, Inc., and JCP Realty Company undertook the construction of the mall, a $27.5 million undertaking beginning in June 1986. The total cost of the entire downtown project totaled $55.7 million, $20 million of which was publicly financed. The above photograph shows the advisory committee at work. Mel Roebuck of Forest City is at upper center, with his arms stretched out. At right center, Bernd Foerster, dean of the College of Architecture, has his head down reviewing some material. Foerster, chair of the advisory committee, was a strong proponent of downtown restoration and redevelopment. The below photograph shows the mall under construction in June 1986. (Both, courtesy Riley County History Museum and *Manhattan Mercury*.)

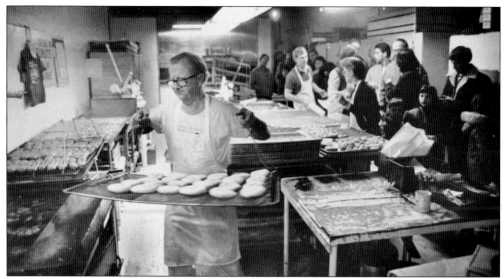

Downtown redevelopment resulted in the dislocation of 67 businesses and 27 residences. Richard "Swannie" Swanson ran an exceptionally popular donut and pastry shop downtown. It was a favorite with KSU students, who thronged to buy his specialty "Yum-Yums," a fried Danish roll. Mall development caused Swanson to close shop in December 1985. This photograph shows Swanson on his last day of business. (Courtesy Riley County History Museum and *Manhattan Mercury*.)

This photograph of the front entrance to the mall shows a facade fitting in scale and design with the older remaining buildings downtown. The mall grand opening was held on October 27, 1987. On the prior weekend, 1,800 people attended a gala dance benefiting the Manhattan Arts Council. As commissioner Kent Glasscock said, the city had taken steps securing its business core. (Courtesy Riley County History Museum.)

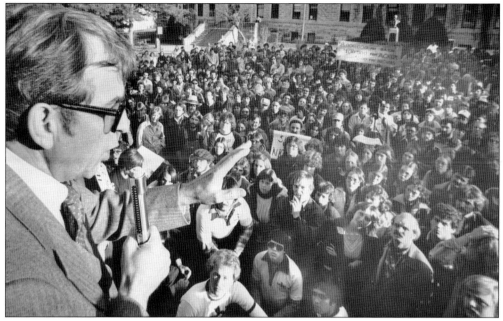

KSU president Duane Acker caused a campus outcry with his decision to raze the burned-out shell of Nichols Hall. On April 4, 1979, between 800 and 1,000 students and faculty gathered to protest his stance. The next day, 120 students descended on the state capitol, and Gov. John Carlin decided to budget $5.7 million toward the restoration of the hall. (Courtesy KSU Special Collections, Hale Library.)

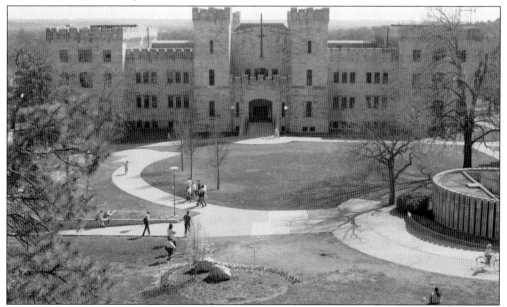

Restoration work on Nichols Hall began in 1981, and construction crews finished their work in 1985. Students, faculty, and administration celebrated the dedication of the $5.58-million restoration of the hall on November 16, 1985. The hall houses a theater and the speech department. This photograph shows the restored building as it has appeared since 1985. (Courtesy KSU Special Collection, Hale Library.)

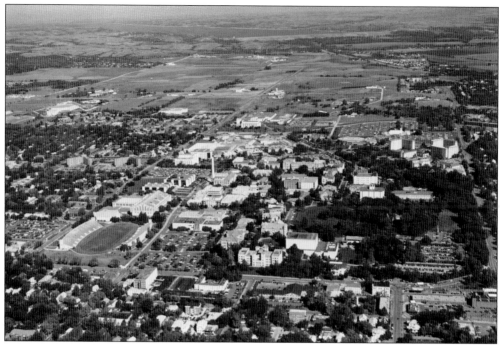

During Jon Wefald's presidency of KSU, student enrollment ballooned, new building on campus continued to meet the needs of a growing student body, and the sports program reached new levels of national recognition. The university's reputations in architecture, engineering, veterinary medicine, and biotech research also improved. This aerial photograph shows a campus now fully surrounded by the growth of surrounding neighborhoods and Aggieville. (Courtesy KSU Special Collections, Hale Library.)

At a time when university presidents seldom hold their positions for more than 10 years, Jon Wefald's 23 years at the helm of KSU is a remarkable accomplishment. Ruth Ann Wefald, photographed here with her husband, actively participated in community affairs and charitable work. (Courtesy KSU Special Collections, Hale Library.)

In the development of the city, there was an interest by some to provide high-quality recreational facilities. The Colbert Hills Golf Course, shown here, opened in 2000. Jim Colbert, former KSU graduate and golf professional, was the driving force in creating this course. Ranked as one of the best courses in the state, the layout was designed to complement the surrounding Flint Hills. (Courtesy KSU Special Collections, Hale Library.)

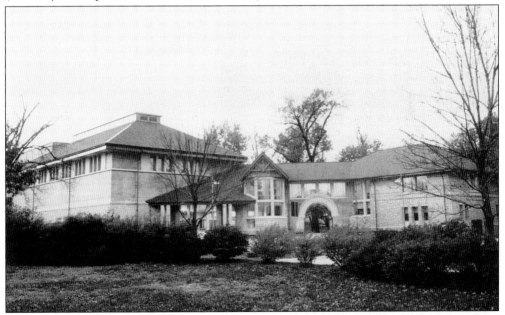

During the 1980s, KSU faculty and administrators took steps to enhance the fine arts. The university possessed a large collection of regional art, but lacked a single place to display it. Headed by KSU First Lady Wefald, a fundraising effort aided by a substantial contribution from Ross and Marianna Beach resulted in the building of Beach Art Museum. The facility opened in 1996. (Courtesy KSU Special Collections, Hale Library.)

The KSU administration realized that it was too expensive to make Ahearn code compliant and meet fan demands for more seats. With student, alumni, and athletic department funding, plus a substantial contribution by alumnus Fred Bramlage, ground breaking for "Bramlage Coliseum" occurred in October 1986. Students quickly named it "the Octagon of Doom." This photograph shows the first game played in the new facility, against Purdue University in November 1988. (Courtesy KSU Special Collections, Hale Library.)

In "the Octagon of Doom," visiting teams always met a formidable Wildcat basketball team. For example, under Lon Kruger's four years as head coach beginning in 1986, the team went to the NCAA tournament every year, and in 1988, played in the Elite Eight, only to lose to archrival Kansas University, which won the tournament. Mitch Richmond, a K-State all-star, is seen here. (Courtesy KSU Special Collections, Hale Library.)

In the two seasons prior to Bill Synder being hired in November 1989, the Wildcat football team had a record of 0-26-1. In 1990, Synder coached an unequaled comeback in K-State football. By the end of the 2011 season, Synder had amassed a 159-82-1 record, received the Woody Hayes award for National Coach of the Year, and was named the Big 12 Coach of the Year. (Courtesy KSU Special Collections, Hale Library.)

Nearly a legend in his own time, students and fans alike honored Coach Bill Synder by naming the football stadium after him when he retired in 2005. Coach Synder was rehired to coach the team in 2008 after a couple of losing seasons. By 2009, Synder had the team back to its winning ways. (Courtesy KSU Special Collections, Hale Library.)

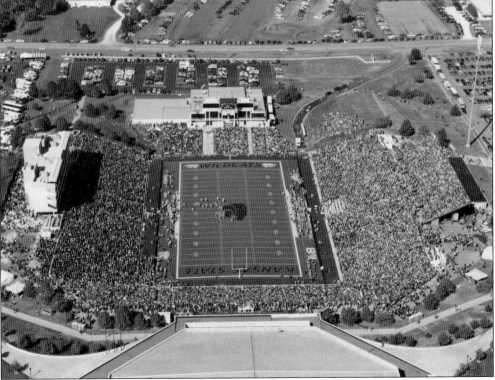

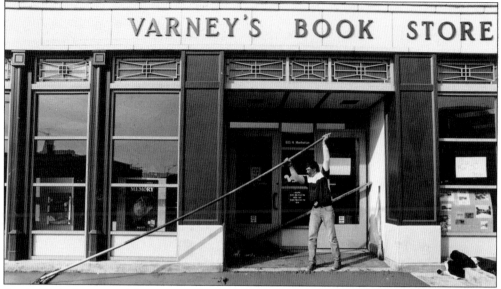

Aggieville is the perennial recreational center for students and alumni alike. After World War II, it served students with retail stores, restaurants, and Laundromats. Today, it is known primarily for its bar and restaurant scene, where it is the location of student postgame celebrations that, on occasion, get out of control. Some businesses are longtime institutions. Two of the best-known businesses are Varney's Bookstore (above) and Kite's Bar and Grill (below). Ted Varney, the son of Guy, ran the bookstore until he retired in 1971, when he sold his interests in it to his partner, Jon Levin. The Levin family still owns the store, which currently serves as the university bookstore. Kites is probably the most recognized sports bar in the city. In 2011, the *Bleacher Report* listed it as one of the best college sports bars in the nation. (Both, courtesy KSU Special Collections, Hale Library.)

The 1993 flood could have produced results similar to those in 1951 had not Tuttle Creek Dam and Reservoir been built. The rains, beginning July and continuing into August, had flooded nearly every watershed contributing to the Missouri River. On July 18, the Army Corps of Engineers opened the spillway gates at Tuttle Creek Dam for the first time. At one point, more than 60,000 cubic feet per second of water coursed into the already-flooded Blue River (above). This resulted in the flooding of homes in the Northview neighborhood, and the rising flood waters in the Kaw River threatened the integrity of the levee system protecting the rest of the city. Residents and city crews worked day and night, sandbagging threatened and flooded neighborhoods. On August 9, the Corps closed the floodgates and many Manhattanites began the painful cleanup of their flooded homes. The below photograph graphically illustrates the erosive, limestone-carving water that flowed through the spillway gates. (Both, courtesy KSU Special Collections, Hale Library.)

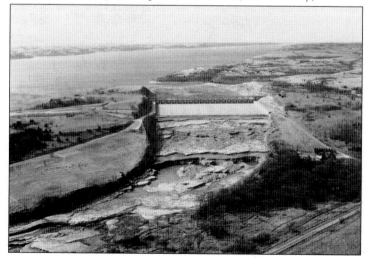

The city suffered a dramatic loss in population when the 1st Division was assigned to Germany in 1996. The 1st Division returned to Fort Riley in 2006, and this produced rapid economic and population growth. As a result, a $97.5-million bond issue to improve and enlarge all of the public schools was approved. This photograph shows the 1st Division parading down Poyntz Avenue in celebration of its return to Fort Riley. (Courtesy City of Manhattan.)

Eastside and Westside Markets have been two of the most popular fresh fruit, vegetable, and garden plants stores in the city. Eastside, the first of the two, was started in 1940. Terry Olson began working for her relatives at the market in 1974, and in 1976, she bought it. In 1981, she opened her place on the west side of the city and, appropriately enough, named it Westside Market. Olson still owns and manages both, and she is a well-respected businessperson in the city. (Courtesy Riley County History Museum and *Manhattan Mercury*.)

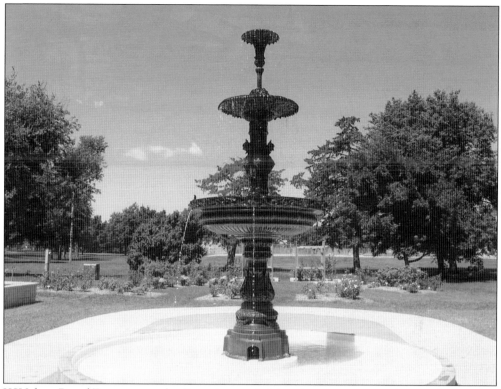

KSU dean Bernd Foerster was a leading advocate for historic preservation in the city. As a teacher and one of the founding board members of the National Trust for Historic Preservation, he inspired hundreds of students to take up preservation causes across the nation. One of the projects he undertook in the city was the restoration of the 1895 City Park fountain. Here, the fully restored fountain is seen in its current location in City Park. (Courtesy City of Manhattan.)

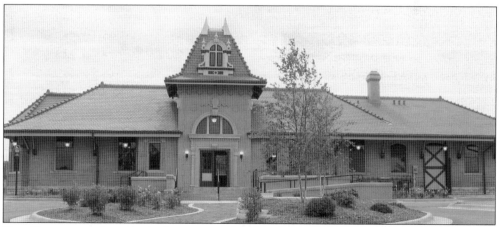

Dean Foerster was also active in the creation of the Manhattan Riley County Preservation Alliance. Formed in 1994, the alliance made restoring the vacated, city-owned Union Pacific depot its first major undertaking. It took 12 years of fundraising efforts and $1.3 million to complete the work. A grand dedication ceremony took place on June 3, 2006. (Courtesy City of Manhattan.)

The city commission continues to expand and develop the airport, given the rising demand for air travel in support of the university and nearby Fort Riley. The city dedicated a new terminal in 1997. By 2010, passenger volume had already surpassed capacity, and the airport advisory committee recommended yet another expansion. (Courtesy City of Manhattan.)

The primary reason air travel has taken off in Manhattan was the result of efforts to acquire jet passenger service. An innovative income guarantee arrangement with American Eagle Airlines led to the initiation of its passenger service in the fall of 2007. This photograph is of the first landing in Manhattan of an American Eagle jet originating in Dallas, Texas. Currently, the airline provides three daily flights to Dallas and two daily flights to Chicago. (Courtesy City of Manhattan.)

City Park Pool, dedicated in 1939, was showing signs of deterioration by 2008. In 2009, voters passed a quarter-cent sales tax to build an aquatic center in City Park, a new pool in the Northview neighborhood, and to revamp CICO Park Pool. Mayor Bruce Snead dedicated this $8.4-million aquatic center in the summer of 2010. (Courtesy City of Manhattan.)

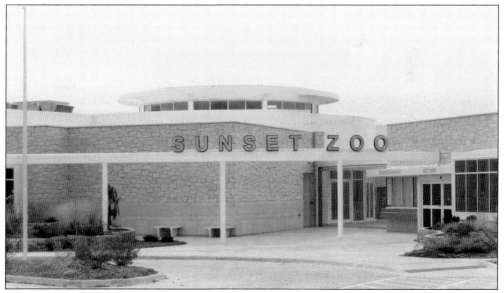

The 2009 quarter-cent sales tax initiative also funded a new zoo education facility. This state-of-the-art building not only provides nature-based programs for youth in the community but also has the technological capability to provide Web-based courses across the state and region. Mayor Loren Pepperd dedicated this $4.4-million project in the summer of 2012. (Photograph by author.)

With the 1st Division in Germany, school enrollment plummeted, and Roosevelt School seemed doomed. School overcrowding, however, followed the Big Red One's return, and the school board successfully proposed a $97.5-million bond issue to expand and modernize all of the schools in the district. This 2013 photograph shows Roosevelt School completely renovated and enlarged. (Photograph by Charles Exdell.)

Over the course of 10 years, public meetings and planning led to a new commercial retail district to the north of the mall. South of the mall, a planned entertainment district broke ground in 2009. In the fall of 2011, city officials and developers dedicated a Hilton Garden Inn Hotel and a city conference center. The hotel, conference center, and public parking garage are shown in this photograph. (Photograph by Charles Exdell.)

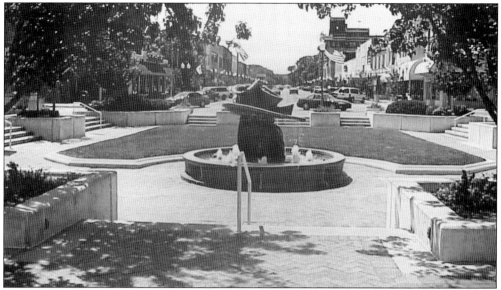

The culmination of more than four decades of downtown restoration efforts began in 2013 with an upgrade of the Downtown Historic District. This photograph, taken from the mall entrance and looking west toward Sunset Hill, shows the portion of Poyntz Avenue that will get a long-overdue face-lift. (Courtesy City of Manhattan.)

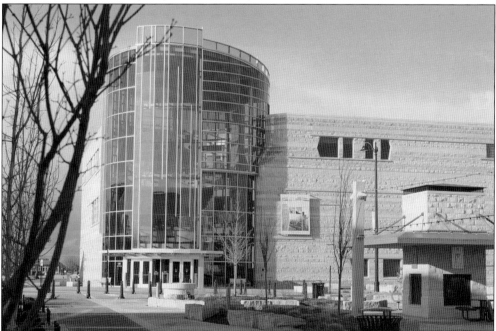

The key undertaking in the South End Redevelopment project was the Flint Hills Discovery Center. This facility highlights the region's ecology, geology, archeology, anthropology, and history. A citizen steering committee guided the project, assisted by a team of volunteer experts. Verner Johnson, Inc., designed the building, and Hilferty & Associates crafted the exhibits. Dedicated by Mayor James Sherow and Gov. Sam Brown, more than 3,000 people attended the opening of the Discovery Center on April 14, 2012. (Photograph by Charles Exdell.)

DISCOVER THOUSANDS OF LOCAL HISTORY BOOKS FEATURING MILLIONS OF VINTAGE IMAGES

Arcadia Publishing, the leading local history publisher in the United States, is committed to making history accessible and meaningful through publishing books that celebrate and preserve the heritage of America's people and places.

Find more books like this at
www.arcadiapublishing.com

Search for your hometown history, your old stomping grounds, and even your favorite sports team.